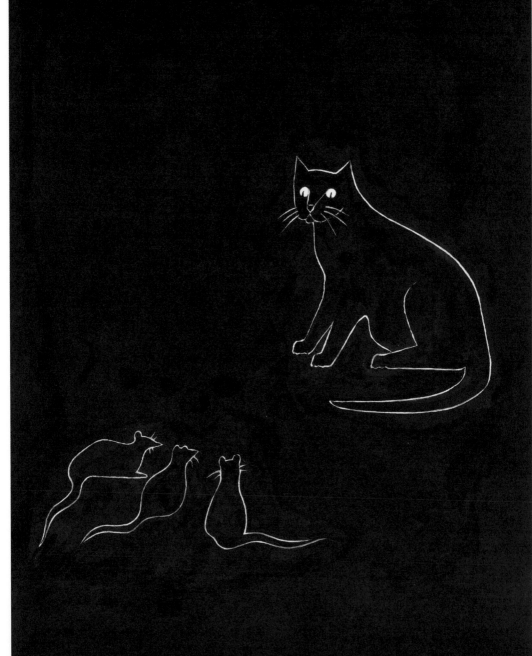

Discoveries from the
Smithsonian's Archives of American Art

# Artful
# CATS

## Mary Savig

———

Princeton Architectural Press · New York
Archives of American Art, Smithsonian Institution · Washington, DC

front cover:
**Lenore Tawney, mail art to Maryette Charlton**
1980, Maryette Charlton papers
Courtesy of the Lenore G. Tawney Foundation

back cover:
**Georges Mathieu, letter to Hedda Sterne**
1961, Hedda Sterne papers
© 2018 Artists Rights Society (ARS), New York /
ADAGP, Paris

previous, page 1:
**Elizabeth McCausland, draft of the copyright
disclaimer page for *Conversations with March*
by Elizabeth McCausland**
ca. 1952, Elizabeth McCausland papers

previous, page 2:
**Charles Green Shaw, drawing of a cat and three mice**
ca. 1945, 11 x 8½ in., Charles Green Shaw papers
—

Charles Green Shaw (1892–1974) was a Renaissance
man who made a career out of exploring his delights.
A trove of sketches and poems in his personal papers
highlights his interest in modern life and abstraction
and also includes whimsical subjects for his children's
books. This drawing likely correlated with a draft
of Shaw's story "The Fable of the Mice and the White
Cat," about a mother mouse who warns her young
children of a big, white cat. They heed her advice,
until one night, a cat appears and entreats them to
share a big piece of cheese. As the story goes, "Unable
to note the cat's color in the dark, the young Mice
accepted the offer. Whereupon the feline seized them
in her claws and greedily crunched them up."

Published by
Princeton Architectural Press
A McEvoy Group company
202 Warren Street, Hudson, NY 12534
Visit our website at www.papress.com

© 2019 Smithsonian Institution
All rights reserved
Printed in China
22 21 20 19  4 3 2 1 First edition

Princeton Architectural Press is a leading publisher
in architecture, design, photography, landscape, and
visual culture. We create fine books and stationery
of unsurpassed quality and production values. With
more than one thousand titles published, we find design
everywhere and in the most unlikely places.

Editor: Sara Stemen
Designer: Paul Wagner

Special thanks to: Paula Baver, Janet Behning,
Abby Bussel, Benjamin English, Jan Cigliano Hartman,
Susan Hershberg, Kristen Hewitt, Lia Hunt,
Valerie Kamen, Jennifer Lippert, Sara McKay,
Parker Menzimer, Eliana Miller, Wes Seeley,
Rob Shaeffer, Marisa Tesoro, and Joseph Weston
of Princeton Architectural Press
—Kevin C. Lippert, publisher

Library of Congress Cataloging-in-Publication Data
Names: Archives of American Art, author. I Savig,
  Mary, author.
Title: Artful cats : discoveries from the Smithsonian's
  Archives of American
Art / Mary Savig.
Description: First edition. I New York : Princeton
  Architectural Press ;
Washington, DC : Archives of American Art,
  Smithsonian Institution, [2019]
Identifiers: LCCN 2018028847 I ISBN 9781616897901
  (hardcover : alk. paper)
Subjects: LCSH: Cats—United States—Anecdotes.
  I Artists—United
States—Anecdotes. I Human-animal relationships—
  Anecdotes. I Archives of
American Art—Catalogs.
Classification: LCC SF445.5 .A73 2019 I DDC 636.8—dc23
LC record available at https://lccn.loc.gov/201802884

# Contents

# Director's Foreword

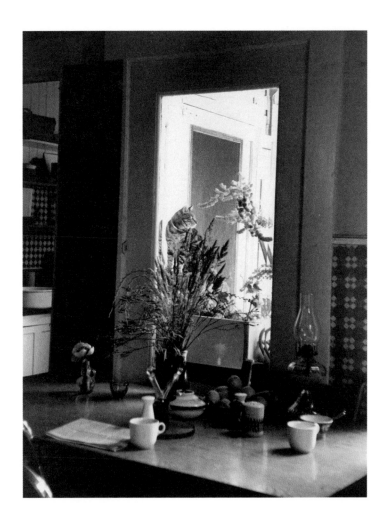

Gulliver in the garden window, 1964
Photograph by Gini Leonard, 9¾ x 8¼ in.
Emmy Lou Packard papers

The Archives of American Art was founded in 1954 to acquire, preserve, and make available the primary sources documenting the nation's artistic heritage. Archival documents including correspondence, sketches, photographs, and diaries are the ingredients for forming a collective art history. They also provide a window into the most personal aspects of an artist's life, including friendships and loves—human and animal alike.

While very few research journeys begin with artists' pets, it is always delightful to discover them along the way. Pets are integral to the day-to-day lives of artists, and so they appear frequently in our collections. In a circa 1947 snapshot among Jackson Pollock's papers at the Archives, we see the artist doting on his pet crow, Caw-Caw. In 1973 Andy Warhol posed with his dachshund Archie for photographer Jack Mitchell. Birds and dogs are undeniably charming, but it is cats that rule the Archives. And while I never imagined writing a foreword to a book about cats in the Archives, when I consider internet stars like Grumpy Cat, with her 8.5 million followers on Facebook, or Keyboard Cat, whose YouTube videos have garnered nearly 100 million views, the project seems inevitable.

In 2017 the exhibition *Before Internet Cats: Feline Finds in the Archives of American Art* was organized by collections manager Susan Cary, curator of manuscripts Mary Savig, and archivist Rihoko Ueno. The diversity of materials and compelling subjects identified for the exhibition prompted further exploration. With cats as the playful common thread, the stories in this book elaborate on the use and value of primary sources in telling a richer story of artists' lives.

Beyond their wily intellect and beauty, cats can reveal interesting aspects of art history. For example, a 1972 oral history interview for the Archives of American Art with land artist Walter De Maria discusses how he bred Burmese cats for a few years in the early 1960s. He details the breeding process and then explains that the cats were often the subject of his drawings. Every evening, after a day of work at the New York Public Library, De Maria drew boxes, rectangles, mountains, castles, and cats. Over time, he experimented with a lighter and lighter touch. This evolved into his significant series of invisible drawings. In the interview, the artist remarks that the drawings were "just on the threshold of visibility.... You didn't know if it was there or wasn't there. In a way it was something like the land work in that it is there but no one can see it." The cats, among other influences, were integral to De Maria's negotiation of presence and absence in his artworks.

This wide-ranging representation of cats in our collections continues to intrigue and amaze my colleagues and me. Just like the artists featured in this book, we have fallen under their spell, and we invite you to join us. With cats as the guides, this book illuminates the important role of the Archives of American Art in bringing nuance and personality to the understanding of the visual arts in the United States.

## Kate Haw

Director, Archives of American Art,
Smithsonian Institution

1. Charles E. Buckley (1919–2011), frontispiece for
*Conversations with March* by Elizabeth McCausland (1899–1965), ca. 1952
8¼ x 6 in., Elizabeth McCausland papers

# Introduction

"Let us never speak of anything but cats," declared art historian Elizabeth McCausland in a 1952 letter to her friend Charles E. Buckley. At the time, McCausland was writing a book about her Siamese cat, March Lion, and Buckley was to provide illustrations (**FIG. 1**). The book project was a departure for McCausland, who had a reputation as a scrupulous biographer of American artists. Over the course of a few years, she and Buckley exchanged dozens of letters about the effortlessly handsome March.

We simply cannot stop talking about cats. They are inspiring, idiosyncratic, and often inscrutable. In this internet era, they are also inescapable. Cats are endlessly beamed onto the screens of our digital devices, distracting us from both the serious and tedious happenings of our lives. Today, March would surely be a meme.

Long before cats dominated the world wide web, they clawed their way into the holdings of the Archives of American Art. A vast interconnected resource comprising more than twenty million items found in six thousand different collections, the Archives is the art lover's information expressway. The Archives preserves primary sources such as correspondence, sketchbooks, photographs, diaries, financial records,

2. Pooh Bear, ca. 1965
Photograph by Jay DeFeo (1929–1989)
1½ x 1½ in.
Jay DeFeo papers

and oral history interviews, ranging from the late eighteenth century to the present day. These rare documents offer firsthand impressions of our nation's artistic heritage. They evoke the atmosphere of art world events and also chronicle the personal lives of artists.

Many primary sources contain key evidence—the who, what, where, and how of the art world. They help map the biographical details, economic circumstances, and technical advancements of artists. And yet, primary sources are not always so straightforward. They often follow their own logic, exposing conflicting narratives and evading easy assumptions about artists' motives. As we rely on archives for their gifts of clarity, we have also learned to appreciate the unruly nature of research. Is it just me, or does this definition recall cats themselves (FIG. 2)?

Archival documents have the potential to reveal some of the most intimate details of artists' personal lives, and among the most endearing is their unrelenting affection for their cats. The plethora of archival documents relating to artists' cats suggests that cats in particular have captured the artistic imagination in remarkable ways. "Cats are in essence their own documents," noted McCausland in her copious correspondence about March Lion. The multifaceted attitudes of cats—alternately expressive and circumspect—make them compelling curiosities. This book highlights how primary sources reflect our enduring—if not inexplicable—fascination with felines. While cats have

**3. Jasper, ca. 1985**
**Photocopy of a photograph by**
**Cyrilla Mozenter (b. 1947)**
**11½ x 8¾ in.**
**Anne Arnold papers**

**4. Romare Bearden (1911–1988),**
**drawing and notes, ca. 1965**
**3¾ x 6 in.**
**Romare Bearden papers**

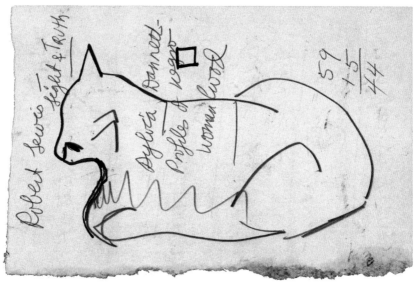

not necessarily had a measurable impact on the history of American art (but don't tell that to the cats), they do take center stage in some of our most intimate records. They are the playful subjects of sketches, humorous topics of conversation, independent studio companions, and beloved members of the family. With this in mind, let us follow the paper tail (FIG. 3).

Cats are everywhere in our collections. You never know where they might appear. Artist Romare Bearden delineated the unmistakable shape of a seated cat on a scrap of paper (FIG. 4). Scattered notes from the 1960s are evidence of Bearden's study of African American history and visual culture, including history texts such as *Light and Truth* (1843) by Robert Benjamin Lewis and *Profiles of Negro Womanhood* (1964) by Sylvia G. L. Dannett. At that time, Bearden was also besotted with his striped feline Gippo. "Gippo is, I think, a very handsome cat. He's perfectly symmetrically striped with gray and tan markings....I keep telling my wife that she should have trained Gippo and used him for ads for cat food because he's a natural ham," gushes Bearden in a 1968 oral history interview with the Archives. Perhaps Gippo, who had made himself at home in Bearden's studio, is the source of this simple sketch and also an indicator of where Bearden's mind wandered as he worked.

Cats are our family members. There are more than seventy million cats living in American households, and we cannot help but form special bonds. Ceramic artist Beatrice Wood frequently described the endearing antics of her cats to her pen pal Elizabeth Stein. "I think of myself as a mother to them and every night around midnight I go back to my workroom where one of my cats lives because she is frightened of the dogs in the house," writes Wood in a 1994 letter to Stein, continuing, "I sit in an armchair so she can curl up in my lap having a loving hug for twenty minutes." In a drawing mailed to Stein in 1991, Wood depicts herself affectionately entwined with one of her cats (FIG. 5).

Cats are our mascots. The Kit Kat Club, an organization of professional and amateur artists in New York City, adopted an adorable kitten as its mascot during a painting expedition down the Hudson Canal in 1895 (FIG. 6). The fuzzy talisman was a direct reference to the club's herald, which festooned the front of the members' boat (FIG. 7). The motif of a wise cat canting above a kitten corresponds to the club's name. "It is said that the name arose from the intention of the founders to watch in which direction the artistic cat should jump, and in a modest way imitate

**5. Beatrice Wood (1893–1998),
self-portrait with a cat, 1991
10¾ x 7 in.
Beatrice Wood letters
to Elizabeth Stein**
Courtesy of Beatrice Wood
Center for the Arts /
Happy Valley Foundation

**6. Kit Kat Club mascot, 1895
Photographer unknown
4¼ x 6¼ in.
Edward Gay and
Gay family papers**

**7. Kit Kat Club outing on the
Hudson River canal, 1895
Photographer unknown
4¼ x 6¼ in.
Edward Gay and
Gay family papers**
An inscription on the bottom of
the photograph humorously reads
"On the racing canal."

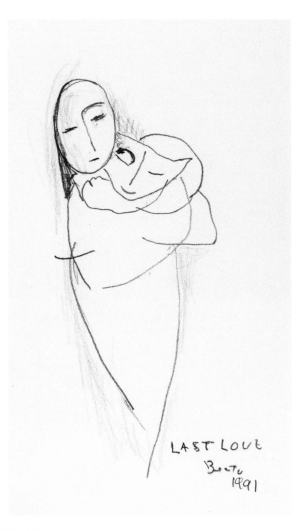

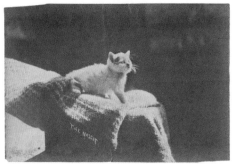

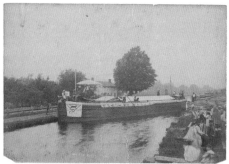

8. Mark Green (1932–2004), postcard to Jay DeFeo, December 19, 1974,
photograph by Mark Green, 1963, 3½ x 5½ in., Jay DeFeo papers

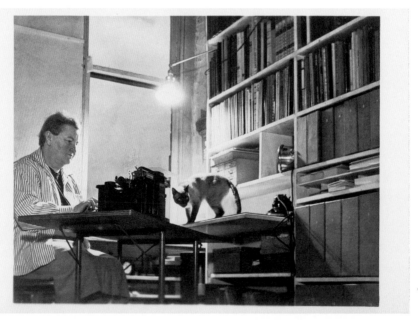

9. Elizabeth McCausland with March, June 1949, photograph by Berenice Abbott
(1898–1991), 4 x 6 in., Elizabeth McCausland papers Masters / Getty Images

the older and wiser beast," noted an 1885 *New York Times* article about the club's origins. The kitten and its more amateur artist friends were to follow the lead of the experienced artists.

Cats are reflections of ourselves. In the 1960s photographer Mark Green owned two cats. Nu was dark and downy, and Albert was light and sleek (FIG. 8). Writing on a handmade postcard of Nu and Albert to his close friend, the painter Jay DeFeo, Green paraphrased a famous quote (well known to cat people, at least) by Aldous Huxley from his 1931 essay "Sermons in Cats": "If you want to be a psychological novelist and write about human beings, the best thing you can do is keep a pair of cats." Cats unapologetically exhibit the contours of emotions—contempt, jealousy, timidity, and joy—that humans feel deeply but typically cannot fully act on. "Unlidded, the cats make manifest this ordinarily obscure mystery of human nature," observed Huxley.

Their demeanor also invites us to project our private selves onto cats. This is notably apparent in McCausland's unpublished manuscript *Conversations with March* (FIG. 9). The book was to feature twenty-two chapters chronicling the life and philosophic pursuits of the young feline. Each chapter delves into the mind of March as he articulates the "long long thoughts of a cat" through rhapsodic riffs on works by George Eliot, Henry Wadsworth Longfellow, Shakespeare, Vachel Lindsay, and Lizette Woodworth Reese, among others. March's virtuoso wordplay is exemplified in "March to Moon," a poem dedicated to a large and haughtier Persian cat named Moon (FIG. 10):

> *At Christmas Time, I write:*
> *That orb from which you draw your name*
> *Floats high over the eastern sea*
> *To be precise, the Atlantic Ocean*
> *Geese and ducks have migrated south*
> *A lonely gull remains*
> *I have not seen an osprey or a tall sandpiper*
> *Only the sky   the sea   the dune*

Of course, "the long long thoughts" in this manuscript measure those of the art critic rather than the cat. McCausland occasionally embeds March's script with self-referential observations. "Words, words, words! Puns, puns, puns! Elizabeth, you are just a mishmash of splendid

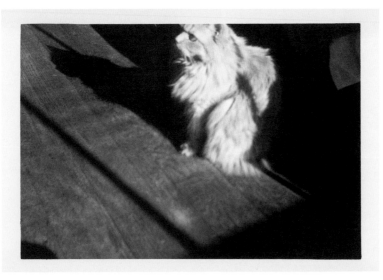

**10. Moon, ca. 1955, Photographer unknown, 3 x 4¾ in., Dorothy C. Miller papers.** Moon was owned by curators Dorothy C. Miller (1904–2003) and Holger Cahill (1887–1960).

rhetoric, a medley of echoes of a world that is no more," exclaims March to McCausland in the first chapter.

Despite its intriguing mishmash of splendid rhetoric, *Conversations with March* was never published. McCausland may have run out of steam. At the time, she was working on a major exhibition and monograph on the painter Marsden Hartley (who happened to be a dog person). Or she might not have found a publisher. Despite the proven popularity of cats in literature at the time, her agent, Mary Squire Abbott, remained skeptical. "Maybe you can do a book about a Siamese that will go well… how wide a market there will be for the flight of fancy you plan I can't say," cautioned Abbott to McCausland in 1951. While McCausland maintained absolute confidence in the book, she disclosed to Buckley that Abbott did "not love cats passionately, so if we persuade her of the importance of being a cat, all will be well."

In a similar spirit, this book celebrates the importance of cats. Its contents are organized around several cat-egories that reflect the various types and uses of archival materials. The first section, "Strike a Pose," shows how cats were the ultimate artist's accessory. In numerous photographs, artists pose with their cats and often with their artworks,

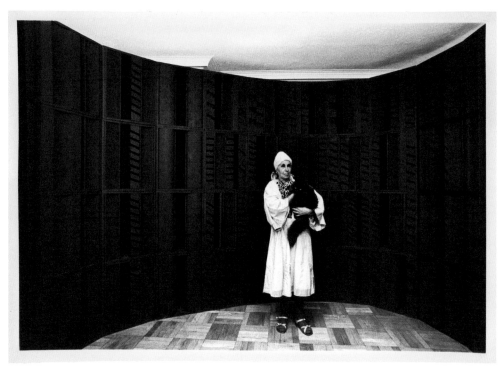

**11. Louise Nevelson (1889–1988) with Fat-Fat in front of a
wall sculpture, ca. 1970, photograph by Geoffrey Clements,
7 x 10¼ in., Louise Nevelson papers**

suggesting a relationship between the two. As an example, photographer
Geoffrey Clements captured both the monumentality of Louise
Nevelson's intricate wood sculptures (which she often painted black) and
her carefully cultivated, glamorous persona (**FIG. 11**). Posing in a white
dress and headscarf, the sculptor contrasts against the black
wall construction behind her and the black cat in her arms. The way in
which Nevelson has centered herself between the resolute sculpture and
the fancy feline encapsulates her exacting control over her own image.

Along similar lines, the next section, "Cats in the Studio," plays
on the seriousness of the artist's studio portrait. For many artists, the
studio is a solitary space for reflection and work. Photographs of artists
in their studios help situate the artist's working practice through the
display of tools and works in progress. They evoke a sense of magic—
where inspiration is realized. These photographs might also yield the

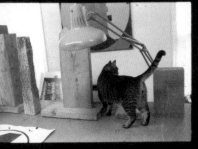

→ 35          → 35A          → 36          → 36A

12. Excerpt from contact sheet of Robert Indiana's (1928–2018) studio in the restored Star of Hope Lodge building in Vinalhaven, Maine, 1981, Photograph by Mary Swift (b. 1926), 1 x 4¾ in., Mary Swift papers

unexpected, especially if a cat is involved. When photographer Mary Swift visited Robert Indiana's Star of Hope studio in Vinalhaven, Maine, she likely planned to capture the unique features of the historical building and his new series of sculptures made from salvaged driftwood (FIG. 12). During her visit, she also took a few delightful photographs of Indiana's cat Chew threading itself through some of the driftwood pieces on Indiana's workbench.

The next category, "Everyday Life," considers how unstaged snapshots help document the day-to-day happenings of artists and their cats. Illustrating this idea is this window into the home of painters Lorri Gunn and Karl Wirsum as they wrangle their toddler daughter, Ruby, and three cats in their Chicago kitchen in 1971 (FIG. 13). A key character in the Chicago art scene, Wirsum thrives on the chaos of his immediate environment, whether it be his kitchen, his studio, or the Chicago streets. From moments of absurdity, Wirsum extracted and distilled memorable images into his vibrant, cartoonlike paintings. Gunn's paintings show fantastical figures formed by undulating bands of bright colors. The artists never depicted their cats in artworks, but the pets were integral to their lives. When they moved to Sacramento in the summer of 1971, soon after this photograph was taken, they carried their four cats— Freddy, Lottie, Barry, and Pesky—with them on the train. During one stop, Wirsum and Gunn walked along the station platform to stretch their legs,

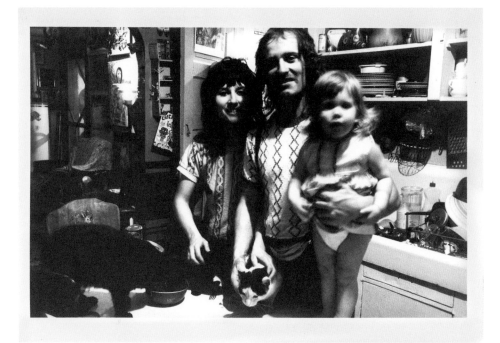

13. Lorri Gunn (b. 1942) and Karl Wirsum (b. 1939) and their daughter, Ruby, standing with their cats in their kitchen, May 1971, photographer unknown, 5 x 7 in., Whitney B. Halstead papers

and when they came to their private roomette, they saw all the cats sitting in a row, looking out the window. "We cracked up and waved to them, pretending we were seeing them off on a trip," recalled Gunn.

The next section, "Cats and the Creative Process," focuses more directly on how cats inform the production of art. Simply put, they make ideal models. A 1939 *New York Times* article "In Defense of Cats" by Jane Cobb extols beauty as the defining quality of cats: "That is the particular talent of the cat. They are all exquisite—even the shabbiest of alley cats have a certain inextinguishable elegance." Indeed, their strong lines and assorted forms make them compelling subjects. While not as accommodating as human models, felines often spend long periods being still—napping or staring into the distance or at walls—and their constant presence makes them more readily available to draw.

Sketches in the Archives offer insight into an artist's creative process. Sketches can be used by artists in many ways, whether as rough

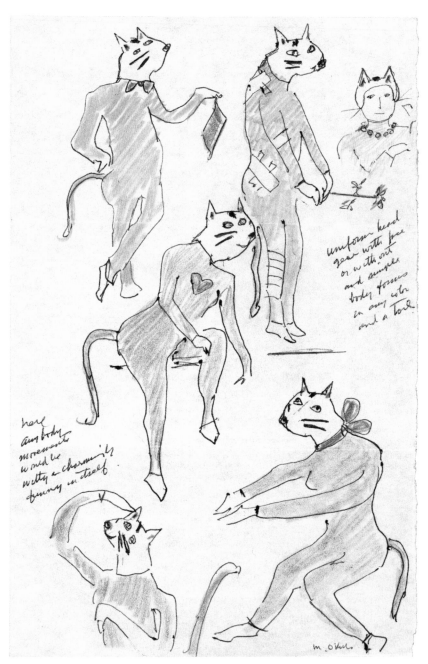

handwritten notes (in image): uniform head gear with face or without and simple body forms in any color and a tail

handwritten notes (in image): here anybody movements would be witty a charming funny in itself

14. Miné Okubo (1912–2001), drawing for Roy Leeper, January 15, 1983, 11 x 8½ in., Roy Leeper and Gaylord Hall collection of Miné Okubo papers

drafts, playful doodles, idle musings, or simply as beginnings—the seed for future work. When artist Miné Okubo was a child, her mother instructed her to draw a cat each day, capturing its personality as well as appearance. After mastering the peculiarities of cats, she sketched out the humorous idea of humans as cats. "Any body movements would be witty and charmingly funny in itself," she notes on a lively drawing (FIG. 14). Perhaps she was inspired by the musical *Cats*, which had debuted on Broadway one year before she made this sketch.

The section "On the Subject of Cats" focuses on how artists, curators, and critics described cats in short stories, poems, and other writings. In many examples, artists and writers departed from their areas of expertise. John Henry Bradley Storrs, known for his sleek modernist sculptures, wrote a whimsical story about how his cat Mimi saved the day, and Beatrice Wood wrote about how her possessive yellow alley cat, Picasso, "got his noise out of joint" when she brought home a new kitten named Miro and a dachshund named Dali.

Collections in the Archives contain records that thoroughly document the biography of an artwork. The section "Cats as Art" shares stories about artists who have made cats the subject of their work. Their attention to felines can be traced through various sources from the Archives, including photographs, exhibition announcements, and scrapbooks. Together, these materials help elaborate on the circumstances of a specific project. We can trace the life of an artwork, beginning with the moment of inspiration to its critical reception in the press. In 1982 photographer David Rasmus sent an exhibition announcement to curator Samuel Wagstaff with the accompanying note: "Sam, it's my 1st real show. pix of flowers cats, ducks. just a little one but i'm so excited!" Rasmus's slightly out-of-focus portrait of a wide-eyed kitten is exemplary of the burgeoning snapshot aesthetic that would become his signature style (FIG. 15).

The final section, "Cat Correspondence," underscores how personal letters bridge the distance between people and their pets. Before social media, we shared the details of our lives through snail mail. Clever postcards by fiber and collage artist Lenore Tawney rival the contemporary cat emoji ubiquitous in today's text messages (FIG. 16). The Archives holds millions of letters that contain facts and anecdotes about the American art world, from seemingly mundane happenings to historical events. This selection of imaginative letters, postcards, and

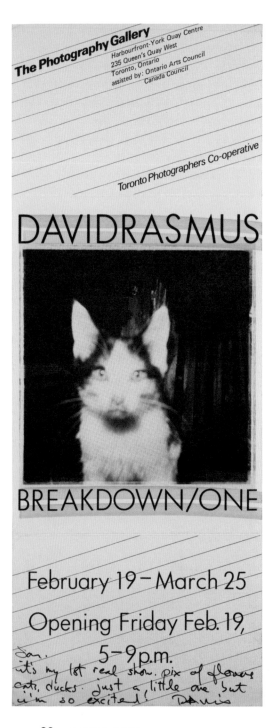

15. David Rasmus (b. 1951), note to Samuel Wagstaff, written on exhibition announcement for *David Rasmus: Breakdown/One* at the Photography Gallery in Toronto, Ontario, 12¼ x 4¾ in., Samuel Wagstaff papers

greeting cards allowed artists to celebrate the quirky personalities of their cats. Such correspondence indexes art world associations. The more intimate their relationships, the more they talk about their cats.

Cats are our muses. Their purchase on our collective imagination has endured and seems never to wane. We will continue to talk about them, sketch them, photograph them, and write about them. As a reflection of this phenomenon, the Archives of American Art continues to grow through new donations, and it will continue to amass primary sources that contain cats as catalysts for historical insight. I hope this book reaffirms all that we hold dear about cats—their absurdity, their affection, their independence, and their beauty. As we continue to pursue new historical inquiries, our feline friends will inevitably be discovered in the Archives, giving us pause (and paws), and reminding us of our own humanity.

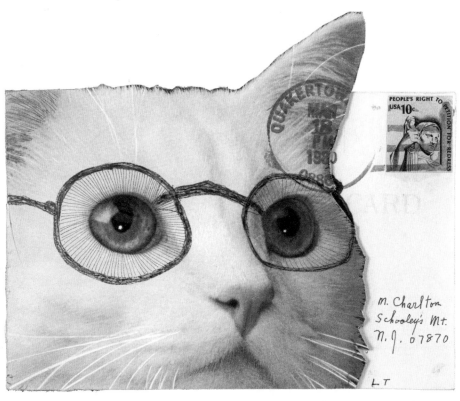

**16. Lenore Tawney (1907–2007), mail art to Maryette Charlton, 1980, 4¼ x 5½ in., Maryette Charlton papers**
Courtesy of the Lenore G. Tawney Foundation

"[My cat] Cluny kisses me every morning ritualistically. And it's so strange that I get my 35mm little camera. And this is when I begin what's going to be a sixteen-year project of shooting these kisses almost every morning."

—**Carolee Schneemann**, oral history interview for the Archives of American Art, 2009

# Strike a Pose

# Gertrude Abercrombie holding some cats

Again and again, painter Gertrude Abercrombie
posed with her many cats, frequently holding up the
feline like a prize.

———

a.
**ca. 1930**
**Photographer unknown**
**1½ x 1¼ in.**
**Gertrude Abercrombie papers**

———

b.
**With her cat and still-life painting**
***There on the Table*, 1935**
**Photographer unknown**
**9½ x 7½ in.**
**Gertrude Abercrombie papers**

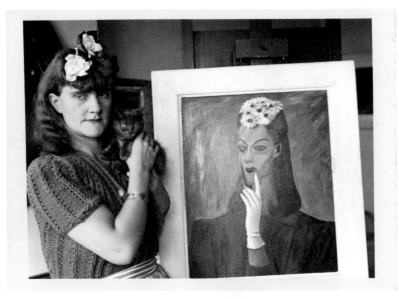

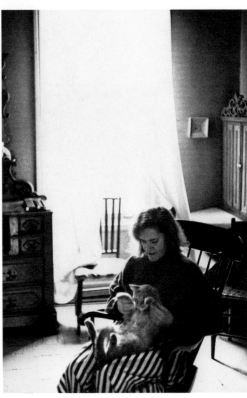

c.
**With her cat and self-portrait
painting
ca. 1945
Photograph by Samuel H. Woolf
5 x 7 in.
Gertrude Abercrombie papers**

d.
**ca. 1965
Photographer unknown
14¼ x 11 in.
Gertrude Abercrombie papers**

# Hedda Sterne with Poussin

ca. 1952
**Photograph by Evelyn Hofer**
10¼ x 8¼ in.
**Hedda Sterne papers**

Romanian-born Hedda Sterne (1910–2011) was a key figure (and one of
the few women) in the legendary New York School of abstract painters.
In this photograph, Sterne—in an elegant black dress—affectionately
scratches the chin of her cat Poussin, in the courtyard of her home at
179 East Seventy-First Street, New York City. Poussin was the model of
many sketches and a few paintings by Sterne. Her husband, *New Yorker*
illustrator Saul Steinberg, drew a portrait of Poussin inside the cabinet
under their kitchen sink; the idea was to keep away mice.

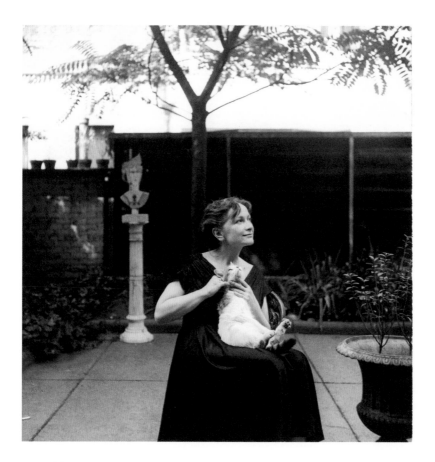

# Berenice Abbott holding a cat

**1968 or 1969**
**Photograph by Arnold H. Crane**
**14¼ x 11 in.**
**Arnold Crane portfolio of photographs**
Reproduced with permission of Cynthia Crane

Berenice Abbott took unforgettable photographs of New York City with her
wide-format camera in the 1920s and '30s. As she shaped how countless people
saw the modernizing urban landscape, she also redefined gender roles. Abbott
unapologetically wore ski pants rather than skirts and lived with her life partner,
art critic Elizabeth McCausland, and their cats for decades. Here, we see Abbott
on the other side of the camera. Fellow photographer Arnold Crane captured
Abbott posing with a furry feline in Maine.

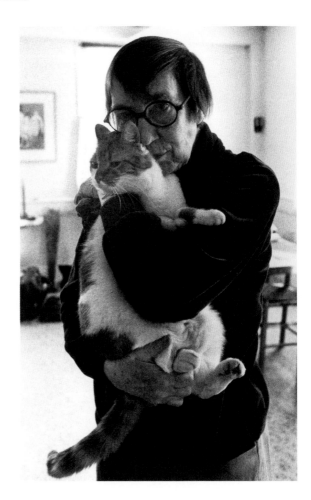

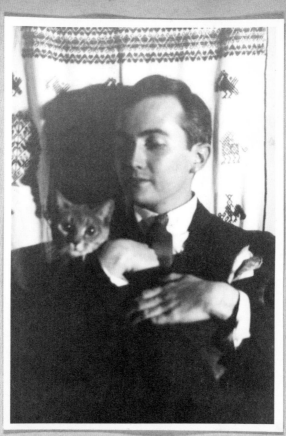

with Rusty — by Robert Byrne  December 1931

## Prentiss Taylor with Rusty
——

**December 1931**
**Photograph by Robert Byrne**
**11 x 9 in. (album page)**
**Prentiss Taylor papers**

Printmaker Prentiss Taylor (1907–1991) was never one to shy away
from an impromptu photo shoot. His photograph albums are filled with
individual and group portraits taken in his home, about town, and on
vacation. Costume designer Robert Byrne staged this photograph of
Taylor with Rusty, a cat belonging to Taylor's landlady in New York City's
West Village. Rusty was also the subject of a 1932 lithograph by Taylor.

## Alfred Lenz with a cat
——

**ca. 1920**
**Photographer unknown**
**4 x 3¼ in.**
**Sara R. Currie papers about Alfred Lenz**

Sculptor Alfred Lenz's (1872–1926) technical experimentations with
the lost-wax method of casting bronze and precious metals helped
advance the sculpture field in the early twentieth century. This delightful
snapshot of Lenz smiling at a small cat draped over his shoulder was
given to his assistant and friend, Sara Rockefeller Currie. Currie noted
Lenz's love of cats on the verso.

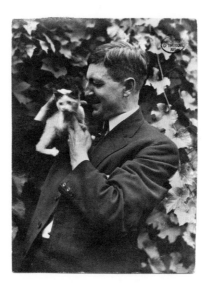

# Paul Suttman and his wife, Elisse, with their cat

---

ca. 1967
**Photograph by Paul Suttman**
7¾ x 5 in.
**Paul Suttman papers**

Paul Suttman (1933–1993) sculpted bronze still lifes, figures, and art historical reinterpretations. This photograph shows Suttman, his wife, Elisse, and their cat riffing on Piero della Francesca's *Pala Montefeltro* (1472–74). Emulating the Virgin Mary, Elisse cradles the rotund feline, who plays the part of the sleeping Christ Child. Paul domes his arms over the pair and an enigmatic egg dangling from the lampshade above. In *Pala Montefeltro*, the suspended ostrich egg symbolizes the Virgin's miraculous conception.

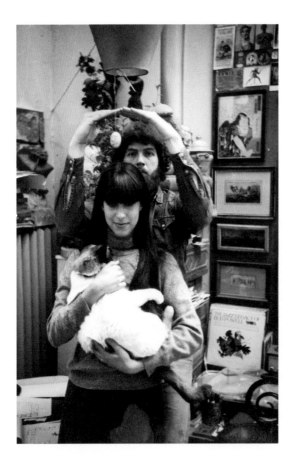

# Charles Biederman in front of
## OUTDOOR SCULPTURE

---

**1937**
**Photographer unknown**
**4¾ x 3½ in.**
**Neil Juhl Larsen research material**
**on Charles Biederman**

In this photograph Charles Biederman (1906–2004) poses with one of his large sculptures and a small kitty in rural Red Wing, Minnesota. At the time, Biederman was living in New York City but constructed this sculpture on the farm property of his brother- and sister-in-law, John and Eugenie Anderson, who were also his most supportive patrons. Disillusioned with the New York art scene, in 1940 Biederman moved to Red Wing, where he reduced forms of nature to geometric abstractions.

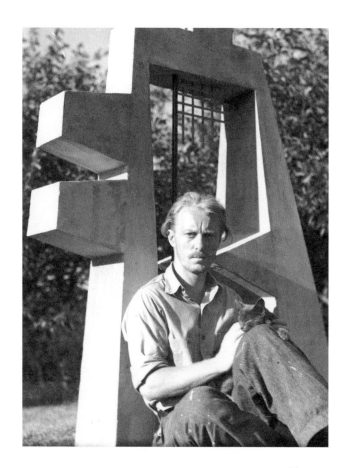

# Miklos Suba with two paintings and Willie

**March 1943**
**Photograph by Mary Morris**
10¼ x 8¼ in.
**Miklos Suba papers**

Born in Hungary, Miklos Suba (1880–1944) moved to Brooklyn in 1924. Trained as an architect in Budapest, Suba took up painting street scenes in a precisionist style. "Suba's art charms and delights," wrote Grace Glueck for the *New York Times* in 1997. Perhaps even more charming and delightful is this carefully composed portrait of Suba seated with his yellow cat, Willie, between two of his paintings, *God Bless Them* (on the wall) and *Portrait of Joralemon Street* (against the sofa).

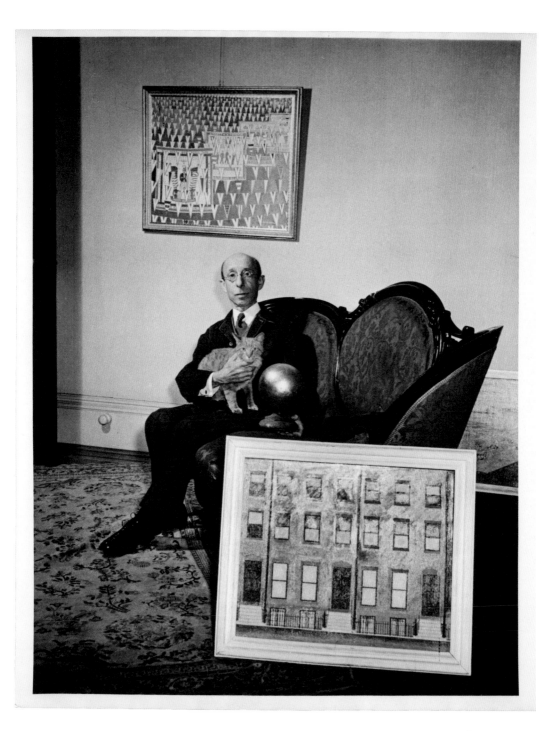

# Ella Witter's cat Tuffy under a Christmas tree

—

**ca. 1950**
**Photographer unknown**
**2¼ x 4 in.**
**Hans Hofmann papers**

This photograph of a four-year-old yellow cat named Tuffy was given to painter Hans Hofmann (1880–1966) by the American painter Ella Witter (1882–1970), an early student at the Hans Hofmann Schule für Bildende Kunst in Munich, which opened in 1915. On the verso, Witter wrote a note from Tuffy's perspective, alluding to Hofmann's signature abstract expressionist style, characterized by juxtaposed planes of color against a flat background. "I love to play with Christmas packages. [They] look like overlapping planes. They'll get pretty dynamic by the time I get through with them."

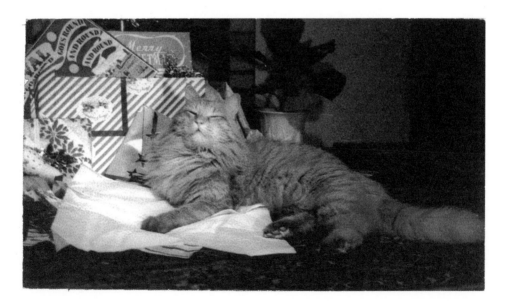

# Elsie Driggs's cat

—

**ca. 1964**
**Photograph likely by Driggs**
**3½ x 5 in.**
**Lee Gatch papers**

As a painter in a precisionist style, Elsie Driggs (1898–1992) was naturally fascinated by the plays on depth and form in this photograph of her dappled tabby lying on a stylized rug. "Isn't this a nice abstract pattern," she writes on the verso. The recipient was her husband, abstract painter Lee Gatch.

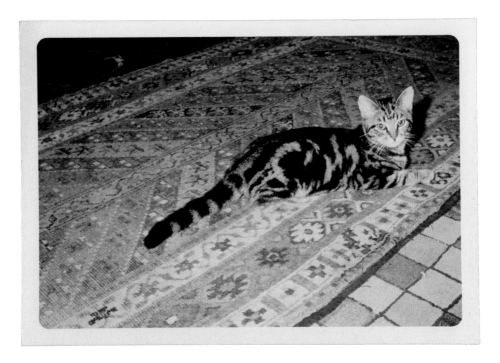

# Lucy Lippard's cat China

**October 24–27, 1997**
**Photograph by Moira Roth, taken with Kathy Vargas's camera**
**6 x 4 in. uncropped**
**Kathy Vargas papers**

In October 1997 feminist art historian Moira Roth (b. 1933) and photographer Kathy Vargas (b. 1950) retreated to the home of art critic Lucy Lippard (b. 1937). Together, they took day trips around northern New Mexico and then relaxed in Lippard's cozy house. Roth's snapshot of Lippard's watchful cat China is a serendipitous and striking composition of yellow and black.

## Anne Arnold's cat Stubbs and one of her rabbits in Maine

—

**ca. 1970**
**Photograph by Anne Arnold**
**7¾ x 9¾ in.**
**Anne Arnold papers**

Sculptor Anne Arnold's (1924–2014) menagerie at her small farm in Montville, Maine, included several cats, dogs, rabbits, pigs, and more. Many of her animals became subjects of her lively sculptures in metal and wood. She took numerous photographs of her pets to use as guides in her studio. Shown here is a tender photograph of a bunny nuzzling her gray cat, Stubbs.

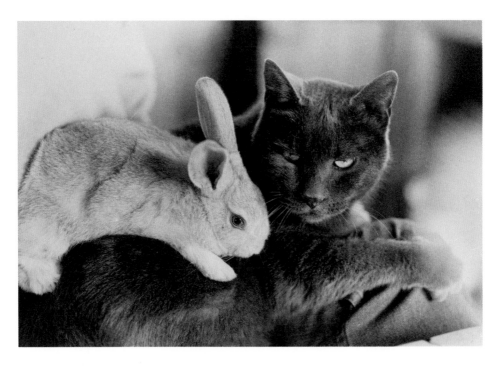

# A cat licking its paw

ca. 1895
Photographer unknown
4¼ x 6¼ in.
Thomas Anshutz papers

Around 1880 painter Thomas Eakins (1844–1916) bought his first camera.
It quickly became integral to his artistic process, and as director of
the prestigious Pennsylvania Academy of the Fine Arts in Philadelphia,
he incorporated photographic methods into the school's curriculum.
Eakins and fellow educator Thomas Anshutz employed the cutting-
edge medium of photography as an aid to their meticulously rendered
paintings. This atmospheric photograph of a sphinx cat licking its paw
was likely taken by someone in the influential circle of Eakins and
Anshutz, though it remains unattributed.

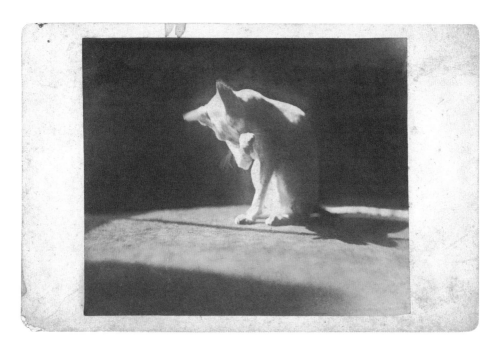

# Jay DeFeo's cat Pooh Bear

ca. 1965
**Photographs by Jay DeFeo**
1¼ x 2 in. each
**Jay DeFeo papers**

Painter Jay DeFeo was a central figure in San Francisco's Beat
generation of artists, poets, and musicians in the 1950s and '60s. She
was known for her unorthodox use of materials that blurred distinctions
between painting, collage, and sculpture. She also experimented with
photography, often focusing her attention on her studio companion,
a cat named Pooh Bear. Here, she documented the serious-looking feline
absurdly posing on a box and in a box.

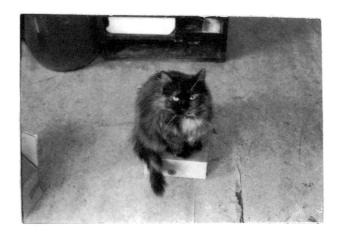

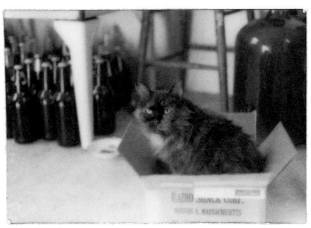

"We found [Gippo]
   in the woods and he has
   a little wildcat in him....
   But now he's happy.
   The studio he feels is his."

—**Romare Bearden**, oral history interview for the
Archives of American Art, 1968

# Cats in
# the Studio

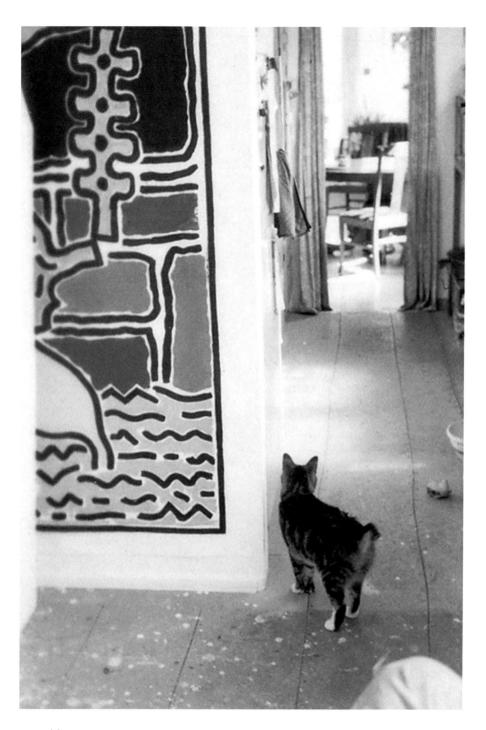

### Cat in Tom Green's studio

1989
**Photograph by Mary Swift**
**1½ x 1 in., excerpt from a contact sheet**
**Mary Swift papers**

For more than twenty-five years, photographer Mary Swift documented the art scene of Washington, DC, for the newspaper the *Washington Review*. When on studio visits, she typically focused her Leica camera on the artist, though a nearby cat occasionally garnered her attention. During a visit to painter Tom Green's (b. 1942) studio in Cabin John, Maryland, Swift snapped a few photographs of a tailless cat wandering down the hallway. Here, the cat has paused next to one of Green's abstract paintings, characterized by crisp lines and glyph-like graphics.

### Maria de Conceição (also known as Sao) in her studio

**Photograph by Mary Swift**
**1 x 3¼ in., excerpt from a contact sheet**
**Mary Swift papers**

Textile and fashion designer Maria de Conceição (b. 1946) created a cozy studio for crafting her popular "wearable art" garments. Surrounding de Conceição in her Washington, DC, studio are spools of thread and piles of remnants for her artworks. Everything was at hand, including an amiable black cat.

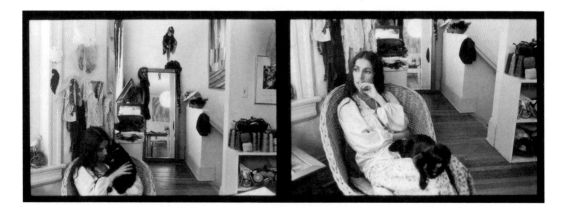

# Fat-Fat in Louise Nevelson's studio (opposite)

—

**ca. 1965**
**Photograph by Ugo Mulas**
**11¾ x 9½ in.**
**Louise Nevelson papers**
© 2019 The Estate of Louise Nevelson / Artists Rights Society (ARS),
New York / © Ugo Mulas Estate

# Cous-Cous in Louise Nevelson's studio (below)

—

**ca. 1965**
**Photograph by Ugo Mulas**
**9 x 11½ in.**
**Louise Nevelson papers**
© 2019 The Estate of Louise Nevelson / Artists Rights Society (ARS),
New York / © Ugo Mulas Estate

Louise Nevelson (1899–1988) repurposed discarded wood—spools, crates, furniture, and the like—into abstract assemblages. During a visit to her studio at 29 Green Street, New York City, in the mid-1960s, photographer Ugo Mulas documented some works in progress. In each photograph, one of Nevelson's splendid felines relaxes on the floor alongside an array of components, all painted a consistent matte black.

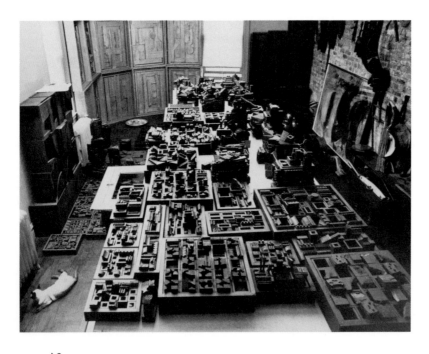

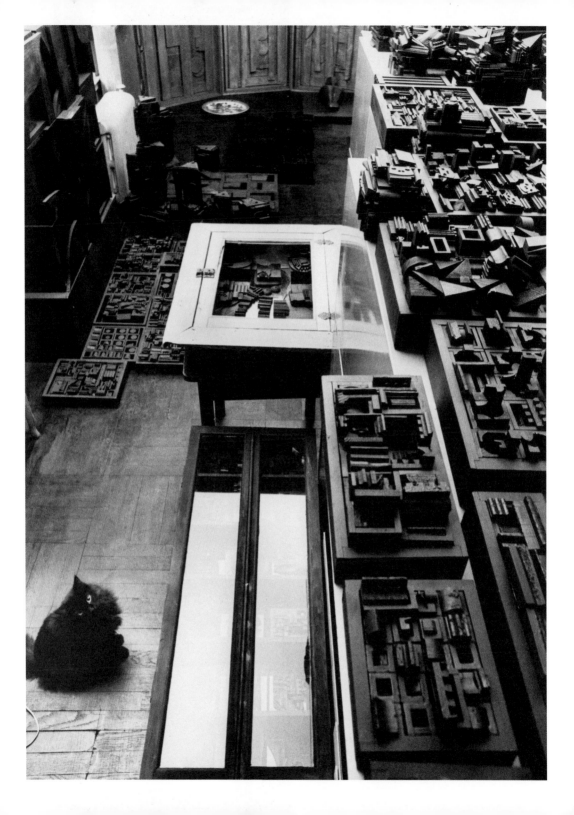

## Jasper Johns with Nancy

ca. 1971
**Photograph by Gianfranco Gorgoni**
**5½ x 1½ in., excerpt**
**from a contact sheet**
**Leo Castelli Gallery records**
© Gianfranco Gorgoni

Jasper Johns (b. 1930) is famous for
his powers of observation. But here,
in this photograph from the Leo Castelli
Gallery records, Johns and his studio
are the objects of observation. His
pet cat, Nancy, was reportedly a gift
from the young Kate Ganz, whose
parents were collectors of Johns's art.
The photograph was taken in Johns's
former studio on East Houston Street
in New York City.

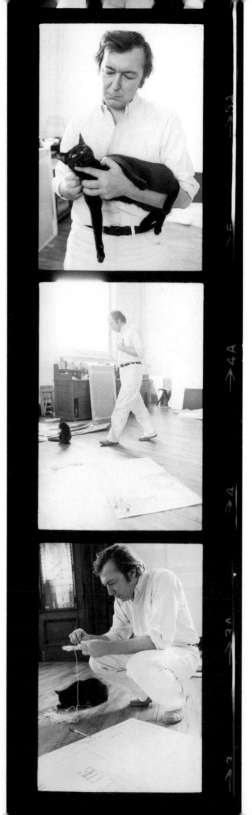

# Frank Stella with Marisol

1975
**Photograph by Michael Tighe**
**11 x 14¼ in.**
**Leo Castelli Gallery records**
Archive Photos / Getty Images

Frank Stella (b. 1936) famously broke off from abstract expressionism on a jagged line toward minimalism. The painter was motivated by the process of art, not the outcome. "I don't just live for the day when I paint that one fantastic painting.... I live to paint and deal with the problems of what painting is and what it's all about," explained Stella in a 1969 oral history interview for the Archives of American Art. Stella grappled with the problems of painting in his New York studio, where his docile feline Marisol carried on with the complexities of being a cat. In this photograph, they take a break from their work to enjoy each other's company.

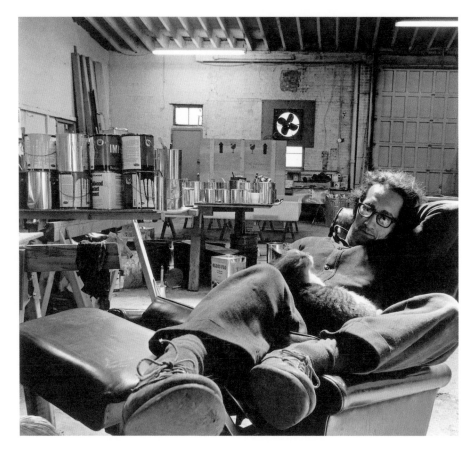

# Beatrice Wood at her pottery wheel

1954
**Photograph by Julius Shulman**
**8 x 10 in.**
**Beatrice Wood papers**
© J. Paul Getty Trust. Getty Research Institute, Los Angeles (2004.R.10)

Beatrice Wood (1893–1998) built a pink and blue home in the Ojai
Valley of California around her pottery practice. In this photograph
taken for the *San Francisco Chronicle*, Wood works at her wheel
with one of her Manx cats looking on. At the time, Wood owned
two Manxes named Miro and Matisse. Across the room is a shelf
displaying jars of ingredients for her signature luster glazes.

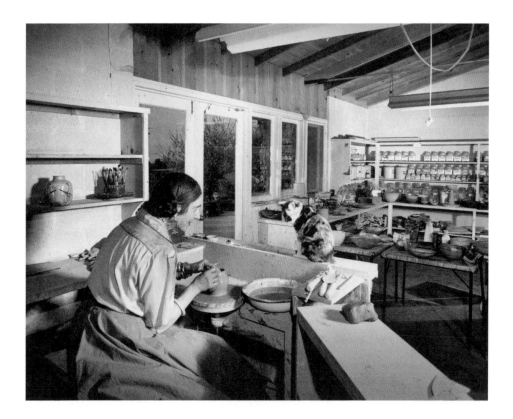

# Rhys Caparn with kitten in her studio

1948
**Photograph by Maya Deren**
10¼ x 8¼ in.
**Rhys Caparn papers**

Perching on a pedestal in the New York studio of Rhys Caparn (1909–1997) is a plaster sculpture of a house cat. Nestled in Caparn's arms is the model. As if collaborators, Caparn and the kitten examine their work. It was part of Caparn's practice to study animals before sculpting them. "I went to the zoo two or three days a week for about two years and drew constantly because I wanted to understand them better," she explained in a 1983 oral history interview for the Archives of American Art.

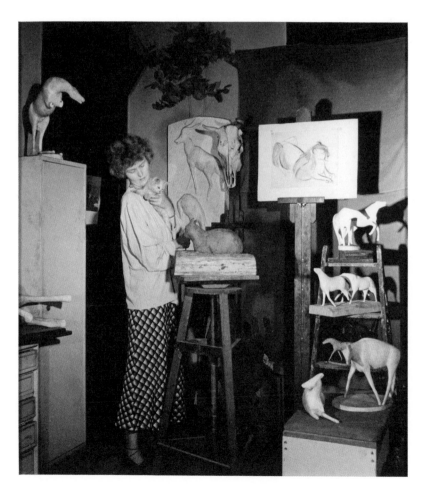

# Carol Wald with a cat in her studio

ca. 1968
**Photograph by Barry Edmonds**
9¾ x 14¼ in.
**Carol Wald papers**

Carol Wald (1935–2000) was a prominent Detroit illustrator whose work appeared in numerous magazines, including *Time*, *Ms.*, and *Fortune*. Here, the artist poses in her studio with an attention-seeking Siamese cat on her shoulder amid many works in progress.

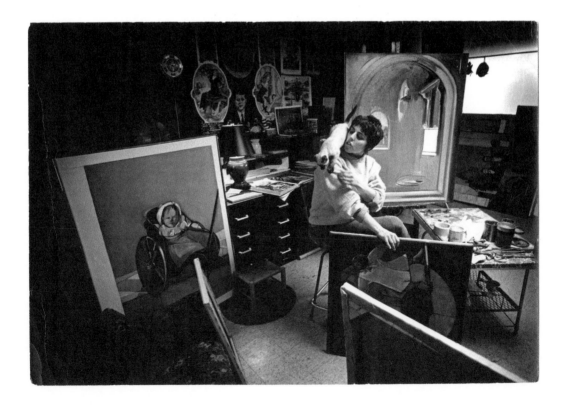

## Pooh Bear in Jay DeFeo's studio

**Early 1960s**
**Photograph by Jay DeFeo**
**10 x 8 in.**
**Jay DeFeo papers**

Artist Jay DeFeo shared a home studio on Fillmore Street in San Francisco with her husband, artist Wally Hedrick, and cat Pooh Bear. In the early 1960s, in the midst of working on her epic masterpiece, *The Rose* (1958–66), DeFeo took this photograph in her studio of the handsome Pooh. On the photograph's verso, DeFeo wrote, "Another photo of Pooh in my studio. The note 'be calm' on wall opposite *Rose*; a reminder." DeFeo worked steadily on *The Rose* for eight years, perhaps under the calming influence of Pooh.

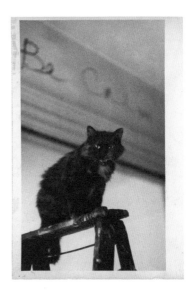

## Judith Linhares with Nelson

**2001**
**Photograph by Stephen Spretnjak**
**4 x 6 in.**
**Judith Linhares papers**

An avowed feminist, Judith Linhares (b. 1940) paints artworks that are rigorously personal and political. Among her vividly painted subjects are talismanic big cats and house cats. For inspiration and company, she usually keeps two resident cats in her studio. This photograph of Linhares playing with her cat Nelson in her studio was taken for the catalogue of her 2001 exhibition, *Sweet Talk*, at the Edward Thorp Gallery in New York City.

# Edna Reindel with Dozy

___

**ca. 1936**
**Photograph by Iris Woolcock**
**7¾ x 9¾ in.**
**Edna Reindel papers**

In 1935—in the throes of the Great Depression—painter
Edna Reindel (1900–1990) received a commission from the
Treasury Relief Art Project, a New Deal arts program,
to create a mural for a meeting room in the Fairfield Court
housing project in Stamford, Connecticut. Reindel's cat Dozy
was a subject of the murals and joined the artist in posing
for official photographs of the completed project, which has
since been destroyed. Reindel later exhibited canvas models
of the mural with her dealer, the Macbeth Gallery.

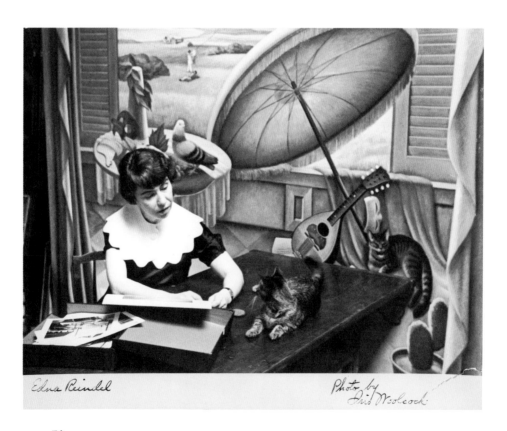

Edna Reindel

Photo by
Iris Woolcock

## Emily Barto at work on her mural ANIMAL TALES

—

**October 6, 1937**
**Photograph by Andrew Herman**
**8¼ x 10¼ in.**
**Federal Art Project, Photographic Division collection**

As part of the New Deal's Federal Art Project, painter Emily Barto (1896–1968) received a mural commission for the Fordham Hospital in New York City. A tame tabby cat served as Barto's model as she brought to life the nursery rhyme "There Was a Crooked Man":

> There was a crooked man, and he walked a crooked mile,
> He found a crooked sixpence against a crooked stile;
> He bought a crooked cat which caught a crooked mouse,
> And they all lived together in a little crooked house.

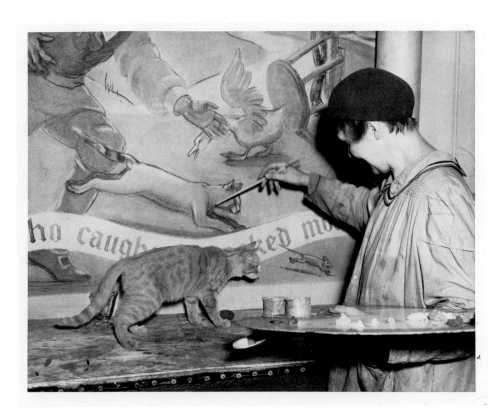

"It is my two pussycats
that help me survive,
and I love them dearly,
even though, really,
as far as I can see, they
are good for nothing."

—**Beatrice Wood**, letter to Elizabeth Stein, 1992

# Everyday Life

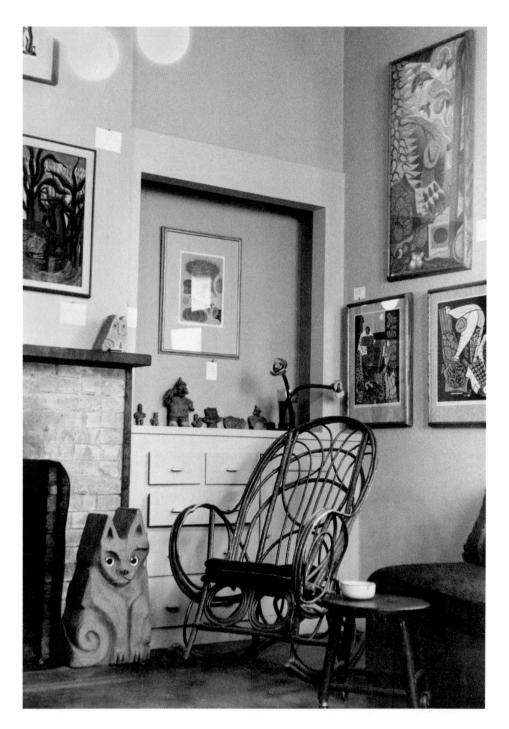

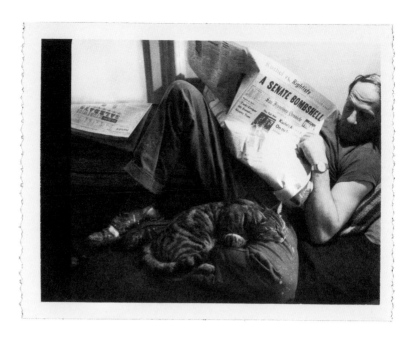

## The Packard-Randall living room and gallery (opposite)

―
**1964**
**Photograph by Gini Leonard**
**9¾ x 8¼ in.**
**Emmy Lou Packard papers**

In the early 1960s muralist Emmy Lou Packard and painter Byron Randall
built a large home in Mendocino, California. The artist couple operated
a gallery out of their living room. On view were their prints, paintings,
and sculptures. Two of Packard's sculptures of cats—possibly inspired by
their cat Gulliver—pose like vigilant sentries around the fireplace.

## Byron Randall relaxing with Gulliver (above)

―
**1963**
**Photographer unknown**
**3½ x 4¼ in.**
**Emmy Lou Packard papers**

In this less formal Polaroid, the ever-present Gulliver cozies up next
to Randall. As the artist catches up on the news, Gulliver rests with not
a care in the world.

# Gertrude Abercrombie's address book

ca. 1967–72
6¼ x 5 in.
**Gertrude Abercrombie papers**

Gertrude Abercrombie loved her cats. She often painted them into
her surrealist landscapes, still lifes, and self-portraits, all layered
with autobiographical references. In her address book, Abercrombie
jotted down a list of Maine Coons she had owned. The list tracks the
cats' names and their eventual fates.

# Gertrude Abercrombie
## and Robert Livingston with a cat

ca. 1945
Photographer unknown
4 x 5 in.
Gertrude Abercrombie papers

Abercrombie achieved local recognition early in her career. A 1944 review in the *Chicago Tribune* noted, "[Abercrombie] paints purely from imagination, using only the moon, a cat, and her own image as subjects....Moonlight and mystery pervade her sketches and there is a curious, dreamlike quality about them." The same could be said for this atmospheric photograph of Abercrombie and a cat, both in profile, and her first husband, lawyer Robert Livingston.

# Felix playing with a toy rat

**December 1993**
**Photographs by Alvaro A. Garcia**
**4¾ x 3 in. each**
**Helen H. Kohen papers**

In 1992 art critic Helen Kohen (1931–2015) introduced gallerist Helen M. Z. Harwood to artist Alvaro A. Garcia. It was love at first sight. One year later, Harwood rescued a weak and tiny cat outside of her World Gallery in Miami Beach. Again, it was love at first sight. The cat was named Felix. Later that year, Harwood and Garcia mailed these photographs to Kohen as a sweet reminder of her important role in bringing the family together. A few years later, in 1995, Felix was best man at Harwood and Garcia's wedding at City Hall in New York City.

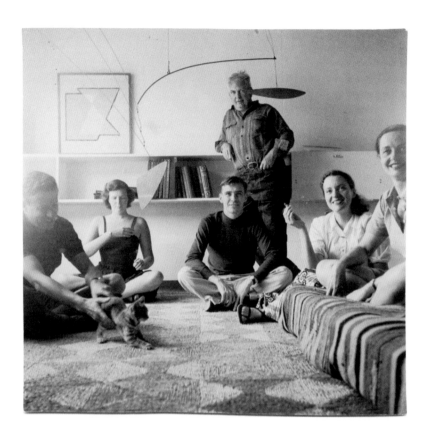

# Gathering at the Breuer I House

ca. 1947
**Photographer unknown**
**4 x 4 in.**
**Marcel Breuer papers**

Left to right: an unidentified man (holding a kitten), Joan McVitty, architect
Edward Larrabee Barnes, sculptor Alexander Calder, Constance Breuer, and
architect Mary Barnes.

In 1947 prolific architect Marcel Breuer (1902–1981) designed his first home, known
as Breuer I, in New Canaan, Connecticut. In this photograph, a group of Breuer's
friends gather in the living room around a playful kitten. Most of the guests
are seated on the woven floor matting, while sculptor Alexander Calder—who
lived just an hour north in Roxbury, Connecticut—leans against painted plywood
shelves. Vibrant works of modern art, such as a mobile by Calder, punctuate the
otherwise modest room.

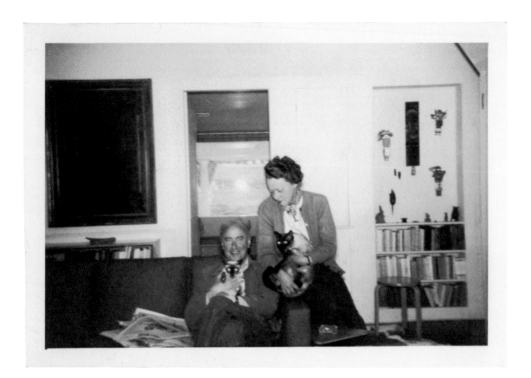

## Kay Sage and Yves Tanguy with their cats

—

**ca. 1950**
**Photographer unknown**
**4¼ x 6¼ in.**
**Kay Sage papers**

Kay Sage (1898–1963) and Yves Tanguy (1900–1966) were
prominent surrealist painters. Sage was born in New York
but spent many years in Italy, where her first one-person
exhibition was staged in 1936. The next year, she moved to
Paris, met Tanguy, and was quickly immersed in his circle of
vanguard artists. They married in 1940. In 1941 they bought
the Town Farm, a house in Woodbury, Connecticut, where
they navigated their international success in the company of
their Siamese cats.

Cat Fanciers' Association registration form with pedigree of Kay Sage's cats

1958
11 x 17 in.
Kay Sage papers

# Geraldine King Tam drawing outdoors

**ca. 1946**
**Photograph by Reuben Tam**
**3¼ x 2¼ in.**
**Reuben Tam papers**

Artists Reuben Tam (1916–1992) and Geraldine King Tam (1920–2015) met while
they were students at Columbia University. Reuben painted vigorous, semiabstract
landscapes, and Geraldine was a botanical illustrator. In 1946 the young couple
spent their first of many summers in Maine. As Reuben took to the rocky coasts,
Geraldine sketched the flora around their rustic cabin on Monhegan Island,
with a kitten as company.

## Prentiss Taylor and Bill Robinson in Harlem <span>(page 68)</span>

February 6, 1932
Photographs by Carl Van Vechten
11 x 9 in. (album page)
Prentiss Taylor papers

Prentiss Taylor led a dynamic career as a lithographer and illustrator. In the 1930s he lived in New York City and was friendly with luminaries of the Harlem Renaissance, notably Carl Van Vechten and Langston Hughes, both of whom were collaborators. Throughout the 1920s and '30s, he documented many of his activities in carefully annotated photograph albums. In 1932 Van Vechten took these photographs of Taylor on Seventh Avenue in Harlem. In the bottom photo, Taylor smiles with famed tap dancer and early vaudeville performer Bill "Bojangles" Robinson. In the top photo, Taylor turns his gaze to a cat minding its business in front of a tailor's shop.

## Cats in the Northeast <span>(page 69)</span>

ca. 1932
Photographs by Prentiss Taylor
11 x 9 in.
Prentiss Taylor papers

Taylor dedicated an entire page of one album to this collage of cats—named Pluto, Mr. Skinneus, and Victoria—he encountered on his travels in 1932 to Watertown, New York, and Peterborough, New Hampshire.

Photographs by
Carl Van Vechten
Harlem 6 February 1932

with Bill Robinson —

Watertown – The Skinners –

Peterborough N.H.

Peterborough N.H.

Victoria – Watertown

Pluto

Pluto
Peterboughs.

Pluto

Watertown – The Skinners –

"When you've [sketched] one thing, like my cat, over and over again then you begin to get playful with him. You don't have to sketch him the way he is. You can fool around and use any color or distort his shape. I think a great familiarity with a subject allows you to play with it. You become relaxed with it. It doesn't matter whether it's just like the cat. In fact, you don't care at all."

— **Sally Avery**, oral history interview for the Archives of American Art, 1967

# Cats and
# the Creative
# Process

# Miné Okubo, painting of a black cat

**1972**
**9¾ x 8¼ in.**
**Roy Leeper and Gaylord Hall collection of Miné Okubo papers**

Miné Okubo's (1912–2001) critically acclaimed book *Citizen 13660*
documented her experiences at two Japanese American internment
camps during World War II. Prior to her family's incarceration,
Okubo was a committed artist and cat enthusiast. Throughout
her life, cats remained a constant presence in Okubo's drawings,
paintings, and correspondence. "Cats alone know how to live because
they maintain their personality and independence," wrote Okubo in
a 1970 letter to a friend, artist Kay Sekimachi. "They give one just
enough for room and board and that's that." She sent this sketch to
her friends and patrons Roy Leeper and Gaylord Hall.

## Lowell Nesbitt, art school sketchbook (opposite)

---

**ca. 1955**
**8¼ x 5½ in.**
**Lowell Nesbitt papers**

Artists as far back as ancient Egypt looked to cats for inspiration. When Lowell Nesbitt (1933–1993) was studying stained glass and printmaking at the Tyler School of Art in Philadelphia, he sketched an Egyptian muse on view in the University of Pennsylvania Museum of Archaeology and Anthropology. Nesbitt highlighted the bronze feline with strokes of mauve.

## Walter Gay, sketch of a cat (below)

---

**1870**
**4¼ x 6 in.**
**Walter Gay papers**

When Walter Gay (1856–1937) was just fourteen years old, living in Boston, he filled the pages of this sketchbook with studies of ducks, squirrels, cows, and cats. In 1876 he moved to Paris and studied with famed French painter Léon Bonnat and also formed a friendship with fellow American expat John Singer Sargent. In Europe, Gay became highly regarded for his portraits of sumptuous interiors—a marked departure from the bucolic subjects of his youth.

# Esther Baldwin Williams, sketchbook of cats

**ca. 1900**
**5 x 7¾ in. each**
**Esther Baldwin Williams papers**

Esther Baldwin Williams (1867–1964) painted cats, flowers, and portraits of the babies and
women of her Boston social circle. She dedicated this entire sketchbook to the subject of
cats, specifically one calico and one orange tabby. With a deft hand, Williams turned swirls
of watercolor into gorgeous cats. In most instances, the cats are relaxing and seemingly
unbothered by the painter's fascination with their coloring and form.

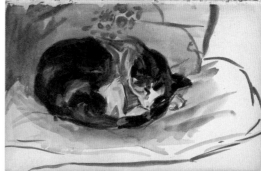
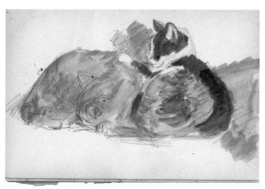

# Naúl Ojeda, sketchbook

**ca. 1975–85**
**12¼ x 9½ in.**
**Naúl Ojeda papers**

Naúl Ojeda's (1939–2002) woodblock prints often depict scenes full of animals, including fish, doves, and, of course, cats. He drew many versions of an animal in his sketchbooks before carving a final image into wood for printmaking. Pops of color accentuate the fantastical shapes of the cats.

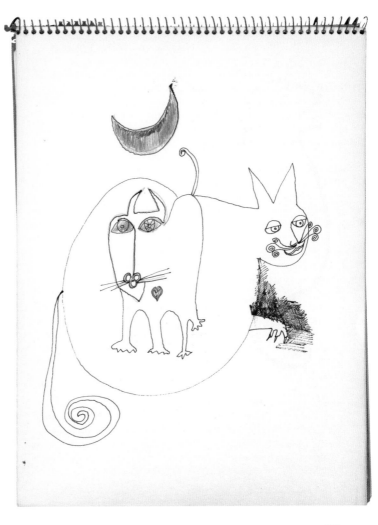

## Olive Rush, watercolor sketch of a cat

**Undated**
**3¼ x 4¼ in.**
**Olive Rush papers**

Based in Santa Fe, Olive Rush (1873–1966) earned recognition for her earth-toned murals and paintings of Southwest scenes. Her papers contain many studies of local landscapes, people, and flora and fauna. Rush modeled this semiabstracted cat with broad daubs of paint. The feline's body is discernible only by one pointed ear and the characteristic curl of a sleeping cat.

## Benson Bond Moore, drawing of Bob

**Undated**
**5½ x 6¾ in.**
**Benson Bond Moore papers**

Benson Bond Moore (1882–1974) was a skilled printmaker in Washington, DC. His papers include more than one thousand drawings and etchings of fauna and flora, from a fuzzy cat named Bob to snails, flamingos, and milkweed. Here, Moore has sketched Bob on his side, with his tail drawn out like a plume of smoke.

## Josef Presser, ink sketch of a cat

**ca. 1950s–60s**
**9 x 12¼ in.**
**Josef Presser papers**

Painter Josef Presser (1909–1967) was never without his sketchbook. Whether he was in a museum or a restaurant, at the circus or a park, or on a bus or a ferry, he sketched his surroundings. This page from one of his sketchbooks depicts a striped cat, rendered in bold lines.

## Palmer Hayden, LE CHAT AUX BIARDS BEACH

**Sketch, ca. 1940**
**5 x 7 in.**
**Palmer C. Hayden papers**

Palmer Hayden (1893–1973) traveled extensively to paint scenes of life. He specialized in serene seascapes of France—where he lived for many years—and also domestic and urban vignettes of African Americans. In 1940 Hayden visited Quebec to sketch the rocky seaside near Mont-Joli. His sketchbook from the trip includes a cursory study of a *chat* (French for "cat").

# Mabel Pugh, sketch of a cat in a rocking chair

**Undated**
**12¼ x 8¾ in.**
**Mabel Pugh papers**

Mabel Pugh's (1891–1986) idyllic illustrations of flowers and landscapes
were reproduced in numerous magazines, such as *McCall's* and *Ladies'
Home Journal.* Her artistic proficiency is evident in this peaceful graphite
sketch of a (presumably) purring cat.

# Unknown artist, watercolor sketch of a snarling cat

---

**Undated**
**7½ x 9½ in.**
**Thomas Hess papers**

Like cats, some documents are cryptic. The unidentified creator of this painting has given full expression to the enigmatic nature of cats in their ferocity and beauty. The body comprises strokes of watercolor and scratches of black ink. Spiraling around the body are allusive words: "attractive," "envy," "despair," "vital," "natural," "stubbornness." The document draws a parallel between the peculiar common attributes of art and cats.

# Peggy Bacon, HECATE

**November 13, 1928**
**7¾ x 7¾ in.**
**Fairfield Porter papers**

Artist Peggy Bacon (1895–1987) sent this print to painter Fairfield Porter.
The title and subject, *Hecate*, alludes to the associations between cats and black
magic. Hecate, a Greek goddess of sorcery, is likely embodied in the striped
cat, mercilessly holding down its prey with a paw. Bacon has created an eerie
atmosphere with a masterful cacophony of hatched and undulating lines, though
she truly loved cats. "We always had dynasties of cats around home when
I was growing up....Cats were the only pets I had. I drew them constantly. I loved
them dearly and enjoyed them as personalities and as models," she explained
in a 1973 oral history interview for the Archives of American Art.

Learning about Commando

# Emily Barto, "A Little Book of Little Cats and Commando"

**April 1948**
**8¼ x 10¾ in. each**
**Emily N. Barto papers**

Emily Barto (1896–1968) illustrated a handful of children's books in the 1940s. This sketchbook, titled "A Little Book of Little Cats and Commando," was possibly the early stages of a new project. In the book Barto highlights the distinct personalities of several felines, including the Siamese cat Commando and the little gray kitty Kitzy.

## Reginald Gammon, storyboard for
## THE CAT WHO WAS DIFFERENT

——

**1962**
**8½ x 8 in.**
**Reginald Gammon papers**

Though Reginald Gammon (1894–1997) was known for his evocative paintings of African Americans, not cats, in 1962 he contributed images to a children's book that chronicles the friendship between a boy and a bespectacled cat. Gammon completed some of the drawings, but the project was never finished. Soon after, Gammon illustrated a different children's book about firemen.

THE CAT WHO WAS DIFFERENT

Written by
Ruth Cushner
Pictures by
Reginald Gammon

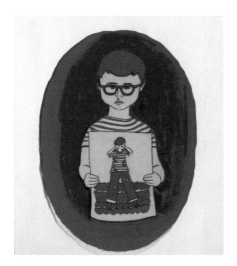

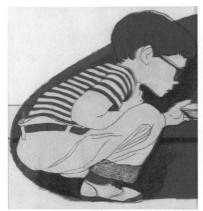

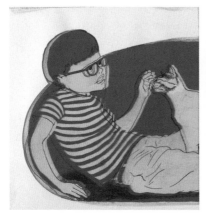

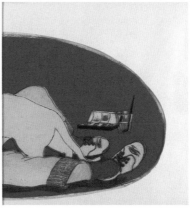

# "Goodness, what a silly thing to write about a cat!"

—**Beatrice Wood**, "The Cat Who Had His Nose Out of Joint," 1946

# On the Subject of Cats

# Cyrilla Mozenter, "Jasper, Adored and Feisty Cat"

**1985**
**11½ x 8¾ in.**
**Anne Arnold papers**

Artist Cyrilla Mozenter wrote this memorial essay and poem about her cat Jasper. Jasper came into the world on the first floor of a Brooklyn brownstone as the unmanageable outlier of the litter. After the rest of his siblings were placed, he was deposited at Mozenter's apartment on the top floor. He stayed. Though Jasper was a terror, Mozenter found pleasure in his devilish ways. Mozenter distributed the posthumous tribute "Jasper, Adored and Feisty Cat" at her first one-person exhibition at 55 Mercer Gallery in New York in 1985 and also sent this copy to her friend the sculptor Anne Arnold.

Jasper is a black cat who is part Siamese and therefore is both very smart and very much a pain in the ass. We've been together for about 11 years. Sometimes I call him "Zip." Jasper is extremely sociable, but mainly likes to be the center of attention. If he's not, he manages to change the situation in a hurry. Jasper eats with his paws when he is feeling jaunty. He sighs and exhales loudly when pleased. Jasper is equipped with fangs due to an overbite. These, coupled with his habit of staring and penchant for power-tripping, lend him a demonic air which gives me a vicarious thrill. Jasper delights in off-beat pleasures; he enjoys having his tail pulled and explodes into purrs when I touch the end of his nose. I wrote a poem about Jasper:

Sometimes I'm blue,

but Jasper is

always

black

1982

## Beatrice Wood, unpublished draft of "The Cat Who Had His Nose Out of Joint"

——

**1946**
**11¾ x 8¼ in.**
**Beatrice Wood papers**

The creative career of Beatrice Wood spanned seven decades, beginning
with her participation in avant-garde art circles in New York City in 1917.
She grew close to Dada pioneer Marcel Duchamp, who encouraged her
to draw. She would later become a celebrated potter in Ojai, California.
The "Mama of Dada" was also the self-described mother of many cats, and
they were a frequent subject of her art and writings. This short story is about
one of her most beloved cats, a yellow alley cat named Picasso. Playing
on painter Pablo Picasso's famous cubist portraits, Wood writes about how
kitty Picasso "got his nose out of joint" when Wood brought home two
new pets, a cat named Miro and a dachshund named Dali. Wood illustrated
the story with her own drawings.

(see transcription on pages 140–42)

## Beatrice Wood with a cat sculpture

——

**1996**
**Photograph by Marlene Wallace**
**9¾ x 7¾ in.**
**Beatrice Wood letters to Elizabeth Stein**

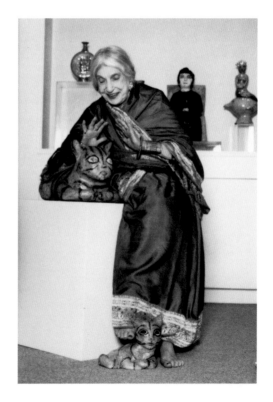

Piccasso Cat

THE CAT WHO HAD HIS NOSE OUT OF JOINT

Once upon a time there lived a horrible huge yellow alley cat,
Piccasso by name, who had a very high opinion of himself. And
no wonder, because for six years he had made his home with a
good natured old lady, and an irritable old man, who loved him
very much, and never interfered with anything he wanted to do.

He was allowed to roam anywhere in the house he pleased, to
curl up on the priceless old French chair, to claw the hand woven
fabric of the rocker by the hearth. It was inevitable therefor,
that he thought of himself as King Pin of all cats.

The old lady had named the cat Picasso after a mad modern
painter, whom she did not understand, but whom she liked to
pretend she did. In her secret mind she considered herself

# John Henry Bradley Storrs, "A Sitting Cat"

ca. 1945
8¼ x 7¾ in.
**John Henry Bradley Storrs papers**

John Henry Bradley Storrs (1885–1956) was a sculptor and writer. He drafted several volumes of memoirs while living in France during World War II and after he returned to his hometown, Chicago. While in France, he was imprisoned several times for transporting wounded victims to hospitals in his Rolls-Royce. This short story, written just after the liberation of France, celebrates a heroic cat, Mimi, who helped incubate chicken eggs on a cold night.

"A Sitting Cat"

SHORTLY after the Liberation the mother of a French boy killed in 1944 gave us his Siamese kitten that has grown up to be a big fat cat, and to whom we gave the, not very original, name of Mimi.

Without getting to be exactly intimate friends with our two dogs, three sheep, fifty or so chickens and ducks and the cow, Mimi is respected by them, and is allowed to move about freely in the barn yard.

During the winter all these animals have the habit of spending their nights in the barn with the cow where they all make warm places for themselves in the loose hay and straw which is strewn thickly over the stone floor.

It was also there that early this spring a setting hen had chosen to establish her nest, and was endeavoring to hatch out a batch of eggs.

Every morning and evening the hen was put for a while under a wire cage to rest, and to eat in peace her couple of handfulls of oats before again being put back on her eggs.

On this particular morning as I was going out to feed the animals, I remembered with a sudden pang that on the previous evening I had forgotten to put the hen back on her job, and that she must still be under the cage, and that by this time the uncovered eggs were as cold as ice and completely ruined; but as I hurried across the yard amid the usual clamorous early morning greetings of its feathery and hairy inhabitants, I had the thought and the hope, that the hen's guardian angel had done something about saving those eggs.

And sure enough, as I stepped into the barn, I saw at a glance the hen still under the cage, but also saw Mimi, curled up, and sound asleep in the hen's nest, where she had evidently spent the whole night, for in due time Mrs. Hen and her large brood were walking proudly about the barn yard.

# Robert Lax, untitled poem
---

**ca. 1990**
**11½ x 8¼ in.**
**Nancy Goldring papers**

Robert Lax (1915–2000) wrote poetry for so many years that, he said, it became
"just like breathing." He stacked words into diagonally descending columns,
exemplified in this poem for his close friend the artist Nancy Goldring. The
illustrated poem offers a peek into the more personal side of Lax, reflecting his
love of humor and fondness for the feral cats that gathered outside his home
on Patmos, Greece. Lax arranged the poem and created the cat with word-
processing software on his computer (which was a gift from pioneering computer
scientist Nicholas Negroponte). "I am sure I laughed more with Bob than any
person I have known," recalled Goldring in an interview about Lax.

my cat hopped
into the computer

& came out
like this

I'm rushing him
to the vet.

# Bob Dombrowski, "Morning"

**From the book *Tides*, 2006**
**4¾ x 3½ in.**
**Jimmy Hedges papers**

Bob Dombrowski's poem "Morning" animates a familiar scenario for many cat owners: the unexpected "gift." In this case, a cat dropped a maimed rabbit at Dombrowski's feet. "The rabbit lies still, at my feet, his eyes on the cat. Radiating pride, the cat casually licks his paw," writes Dombrowski in his characteristic quick-witted prose. The Georgia-based artist wove together his poems and drawings into pocket-size books. This book, *Tides*, was for art dealer Jimmy Hedges.

*Morning*

The cat brought in a rabbit.
He's done this before.
"Here", he says, dropping it at my feet.
"Here. Eat" he says, standing aside.
The rabbit runs.
This has happened before.
Now squealing, hanging from the cat's
mouth, seeing death,
his legs being dragged across the floor,
the rabbit seems to accept.

The cat, a provider,
A hunter bringing home the meat.
Again, he drops the rabbit at my feet.

I pet him. I thank him.
I know he cannot distinguish his prey.
I need him muderous for the rodents.

The rabbit lies still, at my feet,
his eyes on the cat.

Radiating pride, the cat casually
licks his paw.

Fierce determination warring
against acceptance...
a throbbing wish for life balancing
against the hopelessness,
the rabbit runs again.
He almost escapes behind the couch.
The cat is fast.He's caught.

Squealing again in the cat's mouth.

The cat returns the rabbit to me.
he lies with the rabbit, between my feet
under my chair,
his eyes on me.
And he demonstrates.
"Look", he says, "Like this."
The cat rips into a still living belly
with his teeth.
The rabbit does not squeal.
The bloodied living rabbit lies on the floor.
The cat walks away.

There's nothing more I can do for you,
he implies.
You just don't understand what's available,
he implies.

# "Just tell them it's the man who made the cat."

—**Beniamino Bufano**, oral history interview for the Archives of American Art, 1964

# Cats as Art

# Anne Arnold and Christy

Sculptor Anne Arnold (1925–2014) owned a house with a barn in Montville, Maine, where she raised farm animals such as pigs, cows, and chickens, and kept many dogs, cats, and rabbits. Her own collection of cats inspired an entire exhibition in 1969 devoted to the subject at the Fischbach Gallery in New York City. "What made the show so extraordinary was that their cat-ness was neither parodied nor exaggerated but presented straight, so that one had a sense of form completely filled with content," noted one critic in a review for *Art News*.

———
a.
**Anne Arnold, *Christy***
**1987**
**Photograph by Bob Brooks**
**7¾ x 9¾ in.**
**Anne Arnold papers**

—
b.
**Anne Arnold with Christy**
ca. 1987
**Photograph by Bob Brooks**
7¾ x 9¾ in.
**Anne Arnold papers**

# Appealing Sculpture of Anne Arnold

## Cats Made of Canvas Are Painted

### By HILTON KRAMER

FOR some years now, the sculpture of Anne Arnold has been one of the special delights of the New York art scene. It is special in two senses—first and foremost, in the sense of being exceptionally accomplished in its own terms, but also in the sense of appealing to a special taste. Miss Arnold's sculpture has little or nothing to do with the established critical view of the esthetic mission of modern sculpture. It raises no extreme intellectual issues; it does not traffic in far-out forms or radical materials or unfamiliar techniques. It is disarmingly easy to like, and almost shocking in the ease with which it raises something familiar to the level of a modest, but perfect, artistic realization.

In the past Miss Arnold has been at her best in wood-carvings of animals — carvings that were often painted but that were primarily little masterpieces of the carver's art, stunningly accurate, often humorous, always executed with an affectionate spirit. In her new exhibition at the Fischbach Gallery, 29 West 57th Street, she continues her interest in the animal motif, but she has moved into another sculptural medium. These new sculptures — all depicting house cats in various sizes, attitudes, and gestures are made of canvas that has been stretched and shaped over wooden armatures. The canvas surface is painted to form a complete sculpture-in-the-round, and the painting itself, though inseparable from the sculptural conception, is a feat of creative observation in itself.

Some of these cats are monumental in scale; others make their appeal in the most relaxed, domestic terms. There is enormous charm, sensibility and artistic intelligence in this new work, and, as always with Miss Arnold's work, a flawless command of a very difficult realm of craftsmanship. For works of comparable artistry and feeling, one would have to look to the art of older civilizations than our own, to certain folk cultures and ancient crafts.

Yet there is nothing of the archaic in Miss Arnold's work; there is nothing sentimental or merely evocative of other styles. She is, in fact, an extremely original and independent artist who has created her very special body of work out of a keen understanding of the resources of modern art. Her work continues to be a surprise and a joy, and this new exhibition shows her at her very best.

ART NEWS     JANUARY 1970

Anne Arnold's [Fischbach] show reminded one of the Thurber cartoon, "We have cats the way some people have mice." One was taken aback, on entering the gallery, to find that a number of complacent giant tabbies had preceded one there. They seemed to have taken note of your presence and looked away before you had a chance to notice them. There is a ruin in Rome inhabited by zillions of cats, where one sees the stones first and then immediately afterwards the scarcely less immobile felines, who form a very important part of the architecture. So, in the gallery, Miss Arnold's cats seemed to fill out and embellish space in some curious way. What made the show so extraordinary was that their cat-ness was neither parodied nor exaggerated but presented straight, so that one had a sense of form completely filled with content; and yet, despite the charming frankness, these cats seemed also to be objects of another sort, at a further remove from cats than Brancusi's *Bird in Space* from a bird. They were simultaneously faithful reproductions and abstractions. Miss Arnold's previous animals have been carved out of wood; these are of canvas stretched over a complicated wooden armature and then painted. This gives a new effect of softness and mildness, both in the rather cuddly look of the stretched canvas and the way the paint sinks into it, creating something closer to cat colors than painted wood would have. The colors are gorgeous, and one remembers that cats can be pale yellow and orange, vermilion, peach-marmalade colored, ten shades of grey and even blue. My one reservation about the armature-canvas method concerns the very large vertical seated cats. Here the simplified framework results in a streamlining that allows one to wonder whether it's accidental or dictated by problems of construction—a question that doesn't come up in the smaller works where the structure reproduces the required anatomy fluently and without strain. J.A.

b.
**Review clippings**
**December 1969 and January 1970**
**11 x 8½ in.**
**Anne Arnold papers**
"There is enormous charm, sensibility and artistic intelligence in this new work, and, as always with Miss Arnold's work, a flawless command of a very difficult realm of craftsmanship," lauded *New York Times* art critic Hilton Kramer.

c.
**"Anne Arnold Mixes Engineer's and Artist's Insights" in the *Waldo Independent***
**August 27, 1987**
**22½ x 14¼ in.**
**Anne Arnold papers**

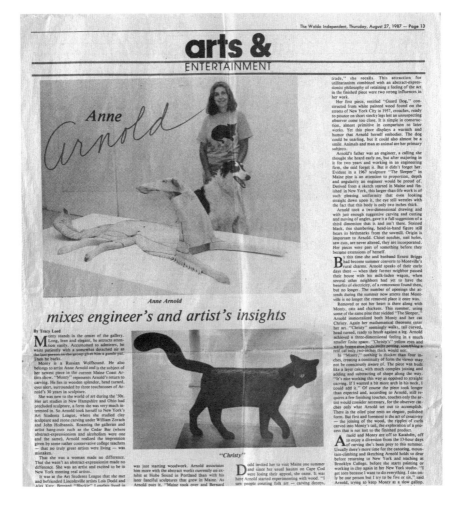

SCOOP

the press and Union league Club
of San Francisco

1960

# Pages from Beniamino Bufano's scrapbook

**1947–60**
**12 x 9 in.; 14¼ x 9¾ in.**
**Beniamino Bufano papers**

Tombstone, a "coal black cat of enormous size," was the unofficial mascot
of the Press and Union League Club of San Francisco at the turn of the twentieth
century. Members were bereft when Tombstone perished in a devastating fire.
To honor the cat's memory, the Press Club commissioned sculptor Beniamino
Bufano (1898–1970) to create a lustrous black marble statue for display.
In 1959 and 1960, Bufano's homage to Tombstone was featured in two separate
print publications, each preserved in a scrapbook of press clippings. *Tombstone*
currently resides at the Black Cat Bar of the University Club, which owns
memorabilia and artifacts from the original Press Club, which closed in 2003.

## Sulton Rogers, cat sculptures

———

**1991**
**Photographs by Jimmy Hedges**
**6 x 4 in., each**
**Jimmy Hedges papers and Rising Fawn Folk Art Gallery records**

Sulton Rogers (1922–2003) "just carved the things he saw at night" while trying
to stay awake during night shifts at a chemical plant in Oxford, Mississippi.
What he saw included saints and haints, hissing snakes, twisted faces, and scaredy-
cats. After Rogers retired in 1984, he dedicated much of his time to his craft and
began receiving national attention. Jimmy Hedges, owner of the Rising Fawn Folk
Art Gallery in Lookout Mountain, Georgia, took these informal photographs of
sculptures in Rogers's home.

# Marisol exhibition announcement

—

**1957**
**24 x 9 in.**
**Stable Gallery records**

This announcement marks Marisol Escobar's (1930–2016) first one-person exhibition at the Leo Castelli Gallery in New York City in 1957 and her playful venture into sculpture, as exemplified by her carved wood *Cat* (1957). In the 1950s Marisol eschewed prevailing art world trends to articulate her own idiosyncratic artistic idiom, informed by her extensive travels in Europe (she was born in Paris), South America (her parents were Venezuelan), and the United States (where she studied modern art). In an interview with Grace Glueck for the *New York Times*, the artist explained that sculpture "started as a kind of rebellion. Everything was so serious....I started doing something funny so that I would be happier—and it worked."

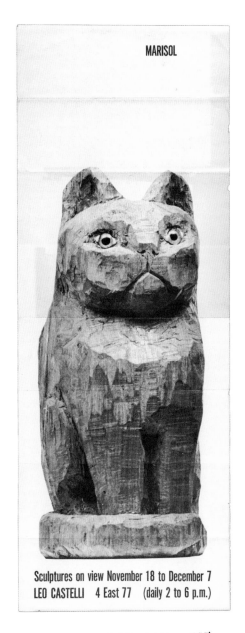

MARISOL

Sculptures on view November 18 to December 7
LEO CASTELLI   4 East 77   (daily 2 to 6 p.m.)

# Dorr Bothwell: All Kinds of Cats

In 1928, when Dorr Bothwell (1902–2000) inherited $3,000 from her aunt, she quit her job as a waitress and booked a trip to Samoa. Her study of Polynesian bark cloth kicked off her career as a printmaker. In 1961, at the encouragement of gallery owner Bill Zacha, Bothwell settled in Mendocino, California, where she documented local cats with her signature strong lines and bold colors. In 1977 Zacha's Bay Window Gallery organized an exhibition of her cat-inspired artworks.

——

a.
*All Kinds of Cats: New Serigraphs and*
*Collage by Dorr Bothwell* exhibition announcement
1977
6 x 4¼ in.
Dorr Bothwell papers

ZACHA'S
BAY WINDOW GALLERY
MAIN STREET    BOX 7    MENDOCINO, CALIFORNIA 95460
PRESENTS:

"ALL KINDS OF CATS"
NEW SERIGRAPHS AND COLLAGE BY
DORR    BOTHWELL
JUNE 10TH TO JULY 3RD    1977
PREVIEW: FRIDAY, JUNE 10TH    5 TO 7

cat + shell.

cat + Tapa

Cat in frangipani tree

b. and c.
**Sketchbook**
**1970s**
**8½ x 6 in.**
**Dorr Bothwell papers**

Sketches of cats (and dogs)
can be found in Bothwell's
sketchbooks from the 1970s.

# Emmy Lou Packard, cast concrete sculptures in Mendocino

1964
12½ x 15½ in.
**Emmy Lou Packard papers**

Emmy Lou Packard's (1914–1998) legacy is closely associated with
Mexican artists Diego Rivera and Frida Kahlo. In 1939 Packard assisted
Rivera with his large-scale murals at the Golden Gate International
Exposition in San Francisco, and then in Mexico, where she grew
close with the legendary couple. Packard's own art career was driven
by the philosophy of making art accessible to all and through her
experimentation with media such as Plexiglas, mosaics, and even
wallpaper. This scrapbook outlines her approach to making cast
concrete animal figures.

Concrete casting in the round,
with gold eyes inset (24" high
by 0" deep). These round cement
sculptures can be covered with
mosaic if desired.

# Diego Rivera with Frances Rich and
# SEATED PORTRAIT #2 OF
# FRANCES RICH IN HER STUDIO

**1941**
**Photograph by Arthur Niendorf**
**9¾ x 8¼ in.**
**Emmy Lou Packard papers**

Diego Rivera (1886–1957) and actress Irene Rich met at the Golden Gate
International Exposition in 1939. A year later, Rich commissioned Rivera to paint
a plaster fresco portrait of her daughter Frances and her white cat. Here, Rivera
and Frances happily pose with the completed work in March 1941. Soon after,
the artwork was destroyed in an earthquake and partially restored.

# Gladys Emerson Cook

Gladys Emerson Cook's (1899–1976) lithographs of cats and dogs appealed to a mass market. This 1941 drawing of a tiger kitten on transfer paper marks the first step of the lithographic printing process. The image is then transferred to a printing stone, typically limestone. From the stone, the final image is printed onto blank sheets of paper.

a.
**Drawing of a cat**
**July 13, 1941**
**6 x 9 in.**
**Gladys Emerson Cook papers**

b.
***Tiger Cats*, from the portfolio**
***Cats and Kittens***
**1955**
**15¾ x 11¾ in.**
**Gladys Emerson Cook papers**

c.
**Design for a business card**
**undated**
**3½ x 5½ in.**
**Gladys Emerson Cook papers**

Cook's cat portraits proved so popular, she incorporated a cat into her business card. Shown here is a mock-up of the card.

"Dear Jay:
People are my serious
photography;
cats my relaxation."

—**Mark Green**, letter to Jay DeFeo, 1974

# Cat
# Correspondence

## Mark Green letter on four photographs to Jay DeFeo

—

**1974**
**Photographs by Mark Green, 1962–63**
**Jay DeFeo papers**

Mark Green (1932–2004), a photographer and arts advocate, was active in the Beat movement in San Francisco and founded the Nanny Goat Hill Gallery (1972–74) to give little-known artists an outlet to exhibit their works. He wrote a short and insightful letter about his creative process to fellow Bay Area artist Jay DeFeo on the verso of these photographs of cats. DeFeo was likely an amused recipient of these photos, as she owned a cherished cat, Pooh.

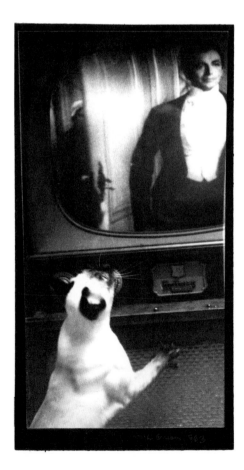

17 Dec 1974

Dear Jay:

People are my serious photography; cats my relaxation. I photograph in streaks of mania sometimes — & then withdraw in lows for long periods —

(more) 1962–

a.
7¾ x 4¼ in.
*verso:*
17 Dec 1974
"Dear Jay: People are
my serious photography;
cats my relaxation. I photograph
in streaks of mania sometimes—
& then withdraw in
lows for long periods—"

b.
6¾ x 4¼ in.
*verso:*
"I can get started again by
photographing cats."

c.
8¼ x 4¾ in.
*verso:*
"Conrad—an alley cat who comes back to
society at times to live the good life and revive
his battered body. One of the few times
I used flash and he did not at all like the flash
bulb pop."

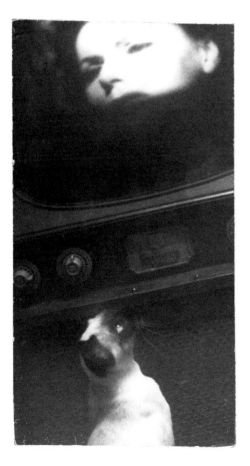

**Mark Green letter on four photographs
to Jay DeFeo**

———

d.
**6¾ x 7¾ in.**
*verso:*
"Anyhow that's why I asked how
you felt about cats."

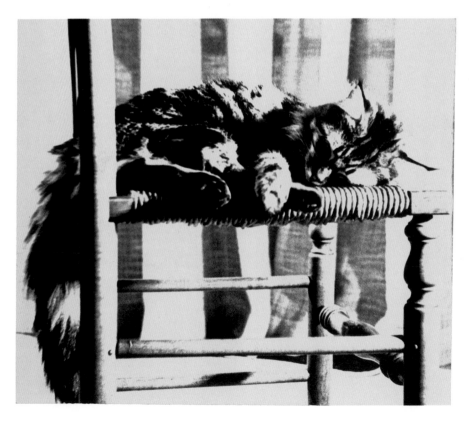

## Carolee Schneemann Christmas card to Joseph Cornell

—

**ca. 1960**
**3¼ x 6¾ x in.**
**Joseph Cornell papers**

Feminist performance artist Carolee Schneemann (b. 1939) decorated her holiday card to her friend the collagist Joseph Cornell (1903–1972) with a picture of her beloved cat Kitch. To Schneemann, Kitch was more than just a cat. He was her muse and her medium. Her film *Kitch's Last Meal* (1973–78) attempted to frame her life from the perspective of Kitch.

Wishing You
a Merry Christmas
And a
Happy New Year

Carolee

# Beatrice Wood letter to Elizabeth Stein

**July 4, 1996**
**11 x 8½ in.**
**Beatrice Wood letters to Elizabeth Stein**
Courtesy of Beatrice Wood Center for the Arts / Happy Valley Foundation

In dozens of letters to pen pal and art collector Elizabeth Stein, ceramic artist Beatrice Wood relished the daily pleasures of her life—chocolate, men, and cats. She often described the daily antics of her cats, observing, "Cats are of course just human beings with four legs instead of just two." In this letter, Wood celebrates Stein's ninetieth birthday. At the time, Wood was 103 years old and a fount of wisdom: "I hang on to the statement of scientists that there is no time....Choosing to live in the timeless; I am at the easiest and happiest time of my life."

Dear Elizabeth: —          July 4. 1996
    It is great you are now at your ninetieth birthday. So you are trying to catch up with me!
    Only I hang on to the statement of scientists that there is no time. Therefore join me in telling everyone you are thirty-two. This allows me to go after young men and plan grabbing husbands from my girl-friends.
    Choosing to live in the timeless; I am now at the easiest and happiest time of my life.
    Join me and my pussy cat.
    My true love
    Hooray for old age!
    Hooray for breaking up homes!
    Hooray for absurdities to and
    alas, hooray for wisdom and peace—!
    Beatrice

8560 HIGHWAY 150 • OJAI, CALIFORNIA 93023 • TELEPHONE (805) 646-3381

Dear Elizabeth :~     July 4. 1996

It is great you are now at your ninetieth birthday! So you are trying to catch up with me!

Only I hang on to the statement of scientists that there is no time. Therefore join me in Falling everyone you are thirty-two. This allows me to go after young men and plan grabbing husbands from my girl-friends.

Choosing to live in the timeless, I am now at the easiest and happiest Time of my life.

Join me and my pussy cat.

Hooray for old age!
Hooray for breaking up homes!
Hooray for absurdities &
alas, hooray for wisdom and
         peace~!

Beatrice

my two cats

# Lenore Tawney mail art to
# Maryette Charlton

Fiber artist Lenore Tawney (1097–2007) developed a deeply personal
visual vocabulary through her correspondence. She intertwined language
with found images, feathers, and flowers to make exquisite assemblages.
Several of her mail art collages for filmmaker Maryette Charlton feature
cats. It was Charlton who encouraged Tawney to use the standard
blank postcards issued by the United States Postal Service for her mail
artworks. These works collapse the boundaries between art and archive,
public and private—a telling reflection of Tawney's creative sensibilities
and her friendship with Charlton.

———

a.
**1980**
**4¼ x 5½ in.**
**Maryette Charlton papers**
Courtesy of the Lenore G. Tawney Foundation

———

b.
**August 1980**
**5½ x 3½ in.**
**Maryette Charlton papers**
Courtesy of the Lenore G. Tawney Foundation

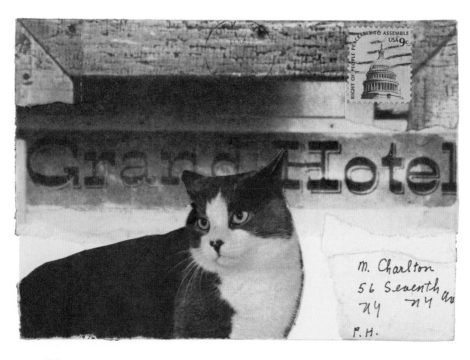

8.80
LT
©

British
Blue

# Joan Mitchell letter to Michael Goldberg

**December 28, 1954**
**10¾ x 6¾ in.**
**Michael Goldberg papers**
© Estate of Joan Mitchell

Joan Mitchell (1925–1992) and Michael Goldberg (1924–2007) fell madly in love around 1951. They had in common an engrossing passion for abstract painting, though their own affair was tumultuous and occasionally violent. Mitchell began this 1954 letter by scrawling out the shapes of two cats along the top of the page. Melancholic after a disappointing evening, Mitchell also doodled a sensual scene of herself lying in repose on a sofa with Goldberg painting her from a nearby chair. The "boid" perched on the windowsill above Mitchell is a teasing reference to Goldberg's pronounced New York accent.

Dearest Michael —
  Ted just left—we finished a bottle
of Scotch—didn't help either of us—barely drunk
just crosseyed & dull. I almost convinced him
to go to an analyst—almost is a great distance.
He's nice when men aren't around. Je suis presque nuts
mon père loves the Greeks—"seen too many
cunts in December," The is the original
wild rice wig wam

  Man I can almost not take it

  Me love—Sweetie pie

  J.

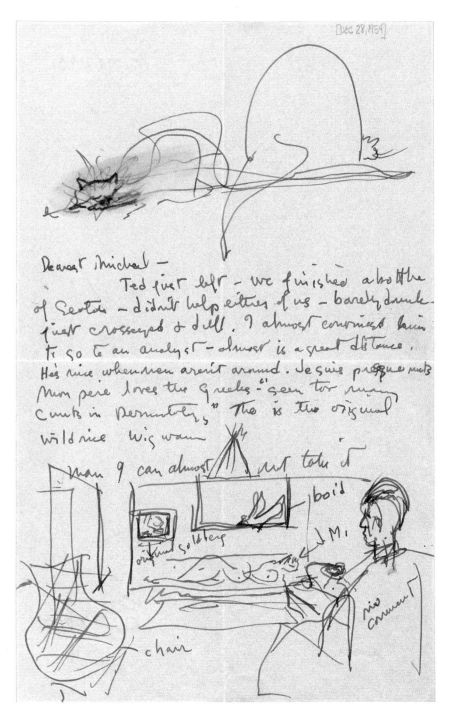

# Judy Chicago letter to Lucy Lippard

___

**1973**
**11 x 8½ in.**
**Lucy Lippard papers**

When painter Judy Chicago (b. 1939) wrote this letter to art critic Lucy Lippard
in 1973, she was working on the *Great Ladies* series in her Santa Monica studio.
These abstract homages to historical women helped set the table for her
watershed feminist installation *The Dinner Party* (1974–79). Here, Chicago reflects
on her role as a woman artist in the changing landscape of the art world. "I think
I can be most effective now through my own work and in training other women....
My thinking is taking me to contemplate what needs to be done in terms of totally
transforming the relationship of the female artist to society...and this means,
I guess, transforming the conception of what an artist is." She tempered the
thoughtful letter with kitty cat and butterfly stickers, as well as an admittedly
"corny" rainbow drawing.

Hiya, Lucy my dear...

    I saw your show at Cal-Arts yesterday and was pleasantly surprised to say that I liked it...you can imagine how my direct Jewish soul has trouble with all the intellectuality of most concept art...no guts, you know, and if it isn't mushy, I can't understand it...At any rate, I thought the show was really interesting, and certainly different from male concept art, more personal, more subject matter oriented, certainly more feminine. Astounding. Maybe, if we talked about female point of view in art rather than the world imagery, it would be clearer. It seems that the use of the world imagery is misleading, making people think that I think that there is a female form or style...i.e. women use certain kinds of x shapes, men use others,..rather than people understanding that it is the way that form is used...like in the concept show...the women use the same form language as the men use, but with different intent often and from a different point of view. Anyway, I don't know why I'm ranting on like this to you, as you certainly know all this. Anyway Congratulations on the show and know that you made one convert to the cause of female concept art on the West Coast.

    Speaking of female point of view, I was just in Tulsa, Okla., in the last of my lecture/workshop gigs...I did a session with female art students, looking at their art...They were very unsophisticated, both esthetically and in terms of female consciousness...which made their art impulses less conditioned by art convention, but more conditioned by their unconscious social conditioning...their art split right into three neat areas, almost astoundingly so...which happened to conform to the 3 major areas of female art in the 20th century, typified by say, Frankenthaler and those women whose art is indistinguishable from mens';x the tradition starting with Cassatt, Laurencin, continuing with Leonor Fini and Marisol...women painting women seeing them from their own point of view...in role, sad, trapped, whatever: and abstract central core imagery, the flower, the vagina, etc. Amazing! My typewriter is making a peculiar noise, what with my trouble with typing doesn't help. This is gonna be a two page letter, as I have a lot of news...

    MS...I wrote them and proposed our terrific idea to them. I also told them how I felt about their non-treatment of the West Coast and afx how I felt about the way they had treated me, the Feminist Art Community out here, Womanhouse, Womanspace, Feminist Art education as we've pioneered it, etc. or rather how they had not treated it and how I felt about it. Turned out that my graduate assistant Faith, did the same thing several weeks before...and neither of us has received any reply at all. I guess I overestimated them and you were more on the money about them than I. Too bad. Anyway, I'll let you know if anything developed.

    Lloyd and I have finally found a studio...a beutiful industrial building in Santa Monica. We will probably start working on it about the first of June and move in at the end of August, as it will take that long to get it together. I am getting ready to settle in for a new 5 year work period... intending to make a change in my work after I finish the great "Great Ladies" series, which should be by the end of the year. I am planning to finish the paintings this summer and then make a suite of prints in the fall on the same theme, which will end the series. Then, I'll get seriously into china painting, which I will be setting up for in my new studio. There are several china painters coming into the Workshop, which, incidentally, is getting filled up. We're up to about 25 students with more requests coming in every day. There will, however, be a dropout rate between now and the fall, so we're going to take more women than we want and hope it settles into about 35 or 36. At any rate, I am planning to make a weekend trip to see you in Maine just before you leave there. How late will you be there? If it seems feasible, both Lloyd and I will come, then I'll come back to LA and Lloyd

will stay in the East for a while...I have to be back on Sept. 15th. If Lloyd were to go to NYC then, would it be too early for him to be able to see anything or anyone? If so, then I would come along and he'll come later. But. if we can work it out, it would be terrific. I'll bring slides of my new work then, Okay? or do you want to see them before I come?

My book is going to be published...it should be out next spring and it is working out perfectly. The West Coast Feminist Press, Wollstonecroft, is going to do it, and my partner, Sheila, is going to design it. In addition, Arlene and her partner, Ruth Iskin, are going to do a companion essay on Female Art History, with a selected bibiliography, which will be published separately, but available with my book* Over the summer, I will be editing it and all that. I would appreciate it if you would not say much about it, except to mention to Susanna that it looks like it is going to be publsihed finally. I haven't signed a contract yet; that is supposed to happen in mid-June and then all will be under way. Phew.

*Also, the whole thing will be designed in a very new way!

Youx know, I really feel that I have reached the end of a period..of my active involvement in organizing, lecturing, etc. I have had a unique opportunity to learn about myself, my position as a woman, the kind of education (or non-education) women are getting in art schools, our real situation in the world, etc. I have repeenished myself esthetically and now I want to id dig in...making my own work and xxaingixx training women from the Workshop to go out and educate other women. I wxh want to try to begin to translate my "cha risma" into concrete methods for educating women...I think I can do it. So, I will be withdrawing from public life inasmuch as I think I can be most effective now through my own work and in training other women to do what I can do with women, so that it can operate on a larger scale. My thinking is taking me to contemplate what needs to be done in terms of totally transforming the relationship of the female artist to society... and this means, I guess, transforming the conception of what an artist is. You know, ai lot of people have hassled me in the last several years about whether my "political activity" was interfering with my art, and it always made me feel vaguely guilty (this might be a 3 page letter, I really have a lot sto tell you)... I suddenly realized that the guilt was similar to the guilt I used to feel when people implied that I was somehow stepping out of "female role"...there is really an "artist role" and I am determined to break out of it...I think I have already. That role demands that the artist, like the woman, be victim...dependent upon the approval of the Establishment, never speaking for herself ("if you have to explain your art, it must be no good," convenietnly forgetting the amoung of explaining that goes on in the magazines and the bar), you have to stay out of politics (as if a non-position was not a position)...etc., etc. all of which is aimed at separating art from the life process and artists from the world..locking us up in some ivory tower, shut off from life and thereby rendering us impotent. It's like capitalism... only some people can have health care, only some people can have good food, only some people can be artists, have art, etc. I talked about some of this in my book , but Now I'm going farther. I think that because of this, art has become focused, not on life and issues of relevance to our lives, but on Art about Art about Art. I have suddenly had this feeling about the artist being like a congressperson, representing the dreams, aspirations, and feelings of a contingency. All the time I have spent with women, organising rapping, doing consciousness-raising, etc. has really put me in contact with my own feelings and those of many women. Now, I havxe to try and trans- late that into work...to really be the vehicle through whom many women speak, feel, express themselves. So, you see, I haven't really been so much in- volved in politics as in finding my community, the community I represent. It's really interesting. This means that the artist again becomes the shaman. Joseph Kosuth once said that I was a witch doctor and I got up tight,

but, of course he was right. Anyway, you know...in this time of great change,
when tedious work is becoming unnecessary, and new ways have to be provided
for people, artmaking and art become essential. If the relationship of the
artist to her community changes, then people can "be involved" in art in
a way they are not now, and the artist can cease to be victim, the barriers
between art forms will break down, the barriers between art "roles" will
end. Anyway, that's what I'm thinking about. I am asking; What has to be
accomplished during this decade so that the women artist no longer has to
be double victim, victim as artist and as woman. Obviously, we need to intro-
duce our historic context into the society...ie. make women's art history
available in every school, develop a new way to speak about women's art and
have that go on on a large scale, send teams of women trained in feminist
educational techniques into the schools around the country to help women
make contact with themselves and work out of themselves, disseminate lots
of information on what 's going on, the new ways of thinking...all of that
hopefully will happen out of the workshop. There are some fantastic women
coming into it! God, I wish you were with us. Then, we'd really have the
market cornered.

Enough...Love and kisses and all that,

*Judy*

This is definitely not a "cool" letter...

Somewhere over the ... oh, no! ← Corny!

# Georgia O'Keeffe letter to Cady Wells

**ca. 1945**
**Dimensions unknown**
**Cady Wells papers**

In the 1940s Georgia O'Keeffe (1887–1986) spent her summers painting in rural
New Mexico. In this letter to fellow New Mexico painter Cady Wells, O'Keeffe
writes about settling into her Ghost Ranch studio for the summer and problems
caused by her "demon" cat. The cat had spent the winter on the ranch of Richard
Pritzlaff, a breeder of chow chow dogs, peacocks, and horses. Soon after they
were reunited, the cat scratched O'Keeffe's close friend and studio manager,
Maria Chabot, and then tried to "squat on a big [tin] carton of very fine herb tea."
The cat was gentle with O'Keeffe herself, perhaps recognizing the painter's
own independent spirit. In 1952, after she moved permanently to New Mexico,
O'Keeffe got the first of six chows.

(see transcription on pages 142–43)

mountains in the sun set — I stood watching rapids in the little mountain stream and counted 12 leaping trout in less than ten minutes — It is a wonderful world ———— and now that one doesn't intend to do any driving one doesn't need to everything looks particularly wonderful —

I hear the cat and he is a demon — He is so mean no one dared go near him over at Richards. Here he is very docile — He scratched Mario three times — Dan still in fact but he is mad at me today because I grabbed him by the neck and threw him out the door just as he was about to squat on a big tea carton of very fine herb tea from Ged Black's .

We kept him shut up the first couple of days. He is out now and I feel like I let a young tiger loose in the country — He is very old with me — All of him wants to scratch and bite but he's always been very gentle with me as he only looks at me meanly and claws the ground with his tail — and doubles up in a curl as if he hates me because for some reason he must not scratch me —

## Edward Weston letter to Charles Sheeler and family

——

1931
11 x 8½ in.
Charles Sheeler papers

This letter begins with an apology. Photographer Edward Weston (1886–1958) was remiss for not responding to a letter from his friend, painter and photographer Charles Sheeler, for six months. Weston had been preoccupied with his large family. "At this counting I have nine cats, another outcast (driven away by the king 'Wuxtry,') and 3+ kittens. The plus stands for a litter born in the brush by a mother adept at concealing. When she proudly brings them out they are, or will be, wild little hellions." Indeed, Weston's property in Carmel, California, was nicknamed Wildcat Hill. In 1947 he published a book of photographs, *The Cats of Wildcat Hill.*

Dear Charles, Musya
and family—
Yr Chagall card of ½ a year ago stares at me reproachfully. Not that I feel duty calling—I really want to write. But once started I find it almost impossible except in all-too-legible chicken scrawls. So most always I just don't start.
    Believe me or not, I am this moment thinking of putting on my Sheeler-coat over a sweater—it's that cool & damp.
    According to your card, you have quite a family! But not to equal mine. At this counting I have nine cats, another outcast (driven away by the king "Wuxtry,") and 3+ kittens. The plus stands for a litter born in the brush by a mother adept at concealing. When she proudly brings them out they are, or will be, wild little hellions.
    Well, I start out with enthusiasm but soon get tied up. Anyway, I think
    of you, of you-all, and of your work. Didn't I hear of another photographer in the family?
    I just finished a successful one-man show in Paris. my first there.
    Large abrazos & my love—
        Edward.

Dear Charles, musya
and family —

Yr Chagallcard of ½ a year ago
stares at me reproachfully. Not that I feel
duty calling — I really want to write. But
once started I find it almost impossible
except in all-too-legible chicken scrawls.
So most always I just don't start.

Believe me or not, I am this moment
thinking of putting on my Sheeler-coat
over a sweater — its that cool + damp.

According to your card, you
have quite a family! But not to equal
mine. At this counting I have nine
Cats, another outcast (driven away
by the king "Wuxtry") and 3+ kittens.
The plus stands for a litter born in
the brush by a mother adept at con-
cealing. When she proudly brings
Them out They are, or will be, wild
little hellions.

Well, I start out with enthusiasm
but soon get tied up. Anyway, I think

## Moses Soyer letters to David Soyer

Moses Soyer (1899–1974) and his family immigrated to the United States from Russia when he was a child. Once settled in the Bronx, Moses and his twin brother, Rafael, showed a predilection for painting. Moses Soyer especially excelled at painting the nitty-gritty happenings and people of New York City. The artist's personal correspondence offers a lighthearted look into their everyday life. In 1940 Soyer sent his only son, David—who was away at summer camp—illustrated letters about the family cats, Bright Eyes and Jester. One letter is written from the perspective of Bright Eyes. "I certainly have grown bigger—haven't you?" writes the handsome feline.

a.
**Summer 1940**
**7 x 5½ in.**
**Moses Soyer papers**

b.
**Summer 1940**
**13 x 8¾ in.**
**Moses Soyer papers**

MY DEAR MASTER and
        PLAYFELLOW—DAVID:
AS Your last Letter consisted almost entirely of questions I think it would not be out of order * if this should contain only answers. So here goes—
1 Yes—I am fine
2 I roll the ball much faster
3 I certainly have grown bigger—haven't you?
4 Yes—I still sit on the blue chair whenever I feel ^like. I consider it my property
5 Yes I do go sit on the fire-escape whenever I feel like having a bit of Fresh air
6 Yes—I still sleep with your daddy. As soon as he gets into bed—I jump in— He does not seem to mind it.
—I guess because

Dear David—

Jester is sitting on my table as I write this letter. He is playing with the telephone wire, the books and the papers. He has grown considerably since you left, and is awfully cute and ful of mischief. You might be happy to know that the GIANTS are having a sensational winning streak. They won six great games in succession.

MY DEAR MASTER and
PLAYFELLOW - DAVID·

AS YOUR last letter consisted
almost entirely of questions
I think it would not be
out of order & if this should
contain only answers. So here
goes ———
① yes — I am fine
② I roll the ball much faster
③ I certainly have grown bigger —
   haven't you?
④ yes — I still sit on the blue
   chair whenever I feel. I consider
   it my property
⑤ yes I do sit on the fire-escape
   whenever I feel like having
   a bit of fresh air
⑥ yes — I still sleep with your
   daddy as soon as he gets into
   bed — I jump in — He does not
   seem to mind it — I guess because

DEAR DAVID —
JESTER IS SITTING ON MY
TABLE AS I WRITE THIS LETTER
HE IS PLAYING WITH THE
TELEPHONE WIRE, THE BOOKS
AND THE PAPERS. HE HAS
GROWN CONSIDERABLY SINCE
YOU                    LEFT, AND
IS AWFULLY    SUSPICION    CUTE AND
FUL OF.                 MISCHIEF.
YOU MIGHT
BE HAPPY
TO KNOW        Ah do I smell FOUL PLAY
THAT
THE
GIANTS ARE
HAVING A SENSATIONAL
WINNING STREAK.
THEY WON SIX
GREAT GAMES    RELAXATION
IN SUCCESSION.

# Georges Mathieu letter to Hedda Sterne

**1961**
**15¾ x 17¾ in., from widest point**
**Hedda Sterne papers**

The papers of painter Hedda Sterne (1010–2011) contain cat-themed correspondence from Georges Mathieu (1921–2012), a French artist highly regarded for his abstract, lyrical paintings. Mathieu sends hugs and kisses to Sterne in this oversize letter embellished with a ribbon of adorable kittens and fanciful gold ink.

> embrassent Hedda
> et lui font mille caresses
> de la part du Roi.

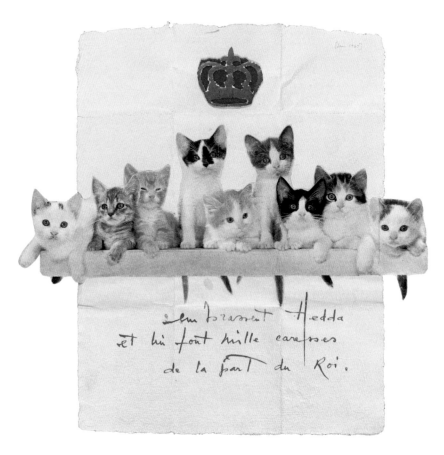

# Charles E. Buckley birthday card for March Lion

**March 24, 1950**
**11 x 8½ in.**
**Elizabeth McCausland papers**

In 1950 art historian Elizabeth McCausland received this beautifully illustrated card on behalf of her Siamese cat, March, from curator Charles E. Buckley to celebrate the occasion of March's first birthday. The noble cat perches atop a pedestal, posing for painters George Inness and Alfred H. Maurer. McCausland had recently published biographies of both artists. The next year, McCausland asked Buckley to illustrate her book about March, which was never published.

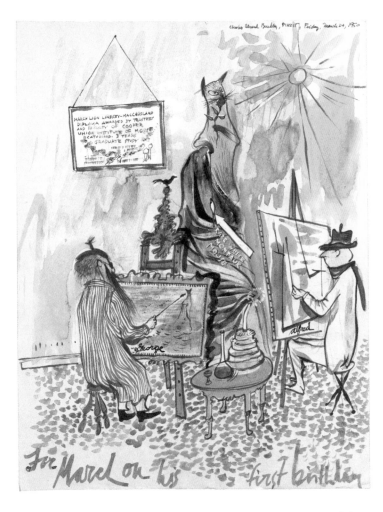

## Charles E. Buckley letter to
## Elizabeth McCausland

**October 22, 1951**
**11 x 8½ in.**
**Elizabeth McCausland papers**

In this letter, Buckley expresses enthusiasm for McCausland's book
project *Conversations with March*, though laments that he cannot afford
to travel from Hartford, Connecticut, to New York City to meet March
and his little brother, Juan Gris (named after the artist).

22 October, 1951

Elizabeth:

Yours just in and read with pleasure. I DO want to collaborate
with you on Marchiana but I cannot rush off hither and yon to
observe the charming creature in action. That will have to be done
of course in time and I suppose the sooner the better. But I am so
poor, so desperately poor. I shall very likely be done sometime
in November, early November. Then we can sit quietly in the soft
sunshine and observe, think and perhaps even talk about the
project. Can't you let me knoe what you really have in mind? Has
it reached the writing stage? How many illustrations? Have you
a publisher? Is it for children? Will I get any money? Illustrations
in black, white, or in color? Prose or poetry, or both? What's it
all about? Be clear; remember I have a wooly mind and must be
helped along.

I feel exactly the same toward Juan Gris that I do toward
March...sight unseen. I think, with a little help from you, that I can
imagine behaviour on the dunes.

Yes. I do want to help. But must know more.........
love from the cats uncle...
C.

22 October 1951

Elizabeth:

Yours just in and read with pleasure. I DO want to
collaborate with you on Marchiana but I cannot rush off
hither and yon to observe the charming creature in action.
That will have to be done of course in time and I suppose
the sooner the better. But I am so poor, so desperately
poor. I shall very likely be done sometime in November,
early November. Then we can sit quietly in the soft sunshine
and observe, think and perhaps even talk about the project.
Can't you let me knoe what you really have in mind? Has
it reached the writing stage? How many illustrations? Have
you a publisher? Is it for children? Will I get any money?
Illustrations in black, white, or in color? Prose or
poetry, or both? What's it all about? Be clear; remember
I have a wooly mind and must be helped along.
    I feel exactly the same toward Juan Gris that I do
toward March...sight unseen. I think, with a little help
from you, that I can imagine behaviour on the dunes.

    Yes. I do want to help. But must know more.........

                    love from the cats uncle...

# Transcriptions

These verbatim transcriptions preserve the exact spelling and punctuation of the original texts. The format, however, has been standardized according to the modified block style for greater clarity.

*Beatrice Wood, unpublished draft of "The Cat Who Had His Nose Out of Joint," 1946*

**Piccasso Cat**

THE CAT WHO HAD HIS NOSE OUT OF JOINT

Once upon a time there lived a horrible huge yellow alley cat, Picasso by name, who had a very high opinion of himself. And no wonder, because for six years he had made his home with a good natured old lady, and an irritable old man, who loved him very much, and never interfered with anything he wanted to do.

He was allowed to roam anywhere in the house he pleased, to curl up on the priceless old French chair, to claw the nand woven fabric of the rocker by the hearth. It was inevitable therefor, that he thought of himself as King Pin of all cats.

The old lady had named the cat Picasso after a mad modern painter, whom she did not understand, but whom she liked to pretend she did. In her secret mind she considered herself

– 2 –

An artist.^too For she had made Picasso a pottery dish with horrible red flowers on it, and his name in green. Naturally he would have preferred a plain dish. He was too bon-vivant however, to make conversation about the plate, in fear of for one moment postponing its interesting consummation.

He was so well fed and the sky so California blue, that nothing interfered with his contentment. If humans ever intruded into his flawless cat life, he climbed on to his wonderful apricot tree, which led him straight to the roof and the white chimeny, next to which he slept sunny mornings. In these exalted heights, no dogs could reach him, nor motors hurt him.

Picasso Cat was completly free of problems and conflicts.

However it is said, ha !—that he who has no problesm, learns nothing about living. Because Picassso was such a nice cat, it was important, alas, that he learn something about life.

– 3 –

So one day a terrible thing happened, perhaps for this very reason, though he had no way of knowing that. A little-gray kitten came to live in his house!

The old lady had found it by accident in a garbage can, crying and trembling, because there was no one to care for it. Lifting it carefully, she brought it to the house in order to give it a bowl of warm milk.

Now the irritable old man was very cross when he saw what she had done. He thumped his cane and told her to return the kitten to the empty lot.

But the old lady did not like to be told what to do. Besides, the moment the kitten had crawled into her arms, she knew it for a special, special pussycat, and immediately she formulated a plan to keep it by her always.

So she cunningly reassured the old man, and gently suggested, "Let us keep it for a little while, then I will find a home for it."

– 4 –

The old man roared, "This house was built for Picasso. No other cat shall live here!"

Afterh the kitten had drunken the milk, nearly falling into the bowl as it did so, it immediately found the priceless old French chair and curled up on it and went to sleep.

There Picasso found it.

Unbelieving he stared at the intruder, then glared at the old couple, thinking they would make the horror vanish from his sight. But it did not move. It ^only opened one eye and smiled at him.

Picasso trembled, thinking the world had to come to an end. His world had. In the immeasurable silence the catastrophe extended itself. There was nothing he could do, but with his own, unique, particular cat gallop, stride from the room.

When the old lady was alone with the kitten, she said, "You darling thing, I want to keep you."

"Please do." replied the kitten without equivocation.

– 5 –

The ~~landlord~~ old man, knowing the old lady was not to be trusted, soon returned and said,

"It is time now you take that kitten and find a home for it elswhere."

The old lady smiled mysteriously to herself, then went to the back of the house, where she took the cream especially reserved for the old man's breakfast, and poured off a little to save for the kitten.

– 6 –

When dinner time came, the kitten was still in the house. treacherously lapping up cream out of Piccasso's own plate, the one that had his own and truly name on it.

Picasso saw the vandalism, and spat. Only that made him feel worse. Try it yourself and see why! Hatred does not make for comfort. Outraged, his hair bristling stiff on his back, he once more dashed out into the black and unyielding night. Nothing had prepared him for the emergency, and on an empty stomach besides.

After the old man had gone to bed, the old lady picked up the kitten from the back porch, where grudgingly he had finally consented it could spend just one night, and on tip toes she carried the kitten to her room. Where, without hesitation, it immediately climbed on to her bed, and there peacefully slept all night without moving, right under her chin, where it was soft and warm.

Of course, the little kitten was never given away. The old lady, though good natured was very determined. From the moment she held the little kitten in her arms, she knew that she would never part with it.

As the days passed, Picasso continued his airs of a prima dona. He spat, beautifully, each time he saw the kitten. He ignored the old couple, except when they gave him something to eat. Only at those moments, in spite of himself, did he make a pretense of love to them, ~~twing~~ twining and

– 7 –

curling around their feet. But that was only because he could not help it. For long ago the habit had been established, and he could not break it. It had been established by his father, and his grandfather, and his great grandfather, and great great great grandfather, and so forth down the ages.

The old lady was concerned that Picasso had such a mean temperament. But in her wisdom she decided it would be a good thing for him to find out about the world as it was. She made up her mind that he should learn that there is never permanent security.

Much of her time she spent with the little cat, whom she named Miro, aftern another modern painter, who made nonsense on canvas, that rich people bought for large sums. Secretly she admired these

– 8 –

gay and provocative paintings, that the old man condemned as degrading. It was her delight to name cats after such free and uninhibited souls.

With its intelligent, intuitive, cat brain, Miro loved her mistress, for she knew the old lady had saved her life. But even more she loved food, – and Piccasso. She followed Picasso about and tired to stroke~~d~~ him with her paws. He only froze at the attention and spat. The kitten even took possession of ~~his~~ the apricot tree that had been Picasso's treasured kingdowm for six years.

From the meadow, Picasso watched Miro sleeping in its branches, and it was like a dagger in his heart. There was no question but that he was in a state of psychological crisis. He would make up his mind to leave his happy home, only to reconsider. The absorbing memories of fillet mignon and saule margery were g reater than his self respect. He invariably showed up for dinner.

To make matters worse, a daschund dog, Dali, also named after a horrib[le] modern painter, who had been away to

the country, came back from his holiday. For years this dog had been Picasso's best playmate. The dog took a liking to the kitten.

Of course, at first glance, he was surprised to find it in the house as Picasso. But the old lady had talked to him and he was open to reason. She had firmly explained, "This little cat had no nice home like you. You must share your comfort and happiness, then you will find more."

"But I want to eat the CAT." Dali said in the best of dog manner.

"Oh, no, you must not." The old lady held out.

"I want you to love this little cat, the way you love Picasso. Look at poor Picasso, ruining his life, because he will not make friends. It is important to learn to get along

– 9 –

with others. It is always easier to fight than to be peaceful."

"Which is why we have wars." barked Dali.

"Stop talking like a human being." snapped the old lady.

"Then I will talk like a dog. Give me meat instead of dog buiscuit, then I will make friends with the kitten."

"Allright, darling." smiled the old lady, who could never be angry long.

To Picasso's further bewilderment, the dog fell in love with the kitten, and paid no attention to him. All day Dali and Miro played together, pretending to bite and scratch each other. The kitten would leap on the dog'b back, and the dog would retaliate by taking Miro's head in its mouth.

The old lady and the old man were very happy over the way these two behaved. They watched them as if they were children romping. A foolish habit. But a nice foolish habit.

Everyones world was full of rose petals, except Picasso's. His nose continued out of joint, and he would not yield an inch.

Because he shut out the world, the world began to shut him out. He found himself in a horrible isolation without anyone to talk to, nor to pet him. He came into the house only to eat, and even that had

– 10 –

lost its flavor.

The old lady was deeply disturbed over his behavior. For she loved Picasso. One afternoon, after he had snarled and growled and worse of all, spit even at her, she said to the old man; "It is I who have failed. I should have taught him how to think."

"No." said the old man, who under his irritablity was really very wise and tolerant. "No one can think for another. You tried you best to show Picasso the way. Now he will have to find it by himself." And he put his arm around the

old lady, for he knew how badly she felt, and how kind she was to all weak things. "Leave Picasso alone. Life will teach him. The only experiences of value, are those one learns oneself."

The old lady wiped away a tear, and picked up the kitten in one arm and the daschund in the other, and sat down with them by the fireplace.

– 11 –

And Picasso, because he was let alone and not interfered with, began slowly to think about why he was so miserable. His mind became very still, adn little by little, through the long slow hours of thought birth, it began to dawn upon him that the old couple still loved him, but that it was he who was not returning the love. And in his wonderful stillness, he became aware, that if one wanted to be happy, one acted with good will, and not with the bad will.

For hours, stretched under the sky, he lay thinking about this. And when he saw it for what it was, he acted. With realizationa and all his cat own dignity, he left the field, walked into the sitting room, where the old lady and the old man, and Dali and Miro were sitting around the fire.

Softly he approached the old lady, and gently rubbed against her feet, then he went up to the little kitten and snuffed of her nice cat smell.

The old lady and the old man looked at each other tenderly.

Picasso saw them exchange a glance, then he gazed at the fire and went down an lay in front of it, and for the first time in weeks, began to purr. He was a noble sight as he did so, with his eyes burning like topaz from a fire within, that eqauled the one without.

He knew that he had done a noble thing, horrible cat that he was. But the knowledge did not bother him. He was too preoccupied with a thought fromthat had come to him from the Chinese. It went like a refrain through his brain, and woke it from being a cat brain into a thinking brain. Like a breeze sweeping through his being, he heard, "Cat, be still, and know thyself for what thou art."

With this new concept of living, his nose once more became straight, and his dear old sweet cat soul awakened.

Goodness, what a silly thing to write about a cat!

– 12 –

For H. P. Roche

          pas bon

          pas digne de Bèa

THE CAT WHO HAD HIS NOSE OUT OF JOINT

By Beatrice Wood
Los Angeles, California.
1946.

### Georgia O'Keeffe letter to Cady Wells, ca. 1945

Cady

your letter today makes me want to cry and put my arms round you very warmly—

I haven't written since Jan here because I was so desperately tired I didn't do much but sleep the first week—Then had to get in order a little bit.

Maria is here—had the house all in order—that was a great help. I didn't stop at your house on my way up here because we had to do shopping both in Santa Fe and Espanola and it was too late but last week when we drove over to get my cat from Richard Pritzlaff we stopped at your house on the way down—It was about four oclock in the afternoon—everything is so lush and green—and blooming—I only picked one sprig of a white vetch that is very beautiful—There were some wonderful white larkspur flowers but I didn't pick any because they would only wilt in the car. Your dogs barked very noisily at us. The only window I looked in was the studio. You have built some over others since I saw it—It looked all packed away. I walked along your porch—out to where you have the little square pool in front of the house—there was no water in it—otherwise every thing looked as neat and orderly as if you were at home—It made me sad. Beatrice was not at home so I left a note for her. I will try again—I wrote in my note to her to come up here if she ever goes driving. We had a wonderful drive over to Richards. I had to get stretchers in Santa Fe. It took what seemed hours to me. That man in the book store was a nervous wreck and the store closing before I got away. We ate supper at the Chinese Restaurant then drove on in the sun set—evening light—then the moon—It was 10:30 when we got there. I had never had that drive coming in this direction. It was really wonderful— yes I thought of you—The snow on the Sangre de Christos— the first view of the Pedernal—with the lines and lines of other mountains in the sun set—I stood watching rapids

in the little mountain stream and counted 12 leaping trout in less than ten minutes—It is a wonderful world—and now that one doesn't intend to do any driving one doesn't need to every thing looks particularly wonderful—

I have the cat and he is a demon—He is so mean no one dared go near him over at Richards. Here he is very docile—He scratched Maria three times—I am still in tact but he is mad at me ^today because I grabbed him by the neck and threw him out the door just as he was about to squat on a big tan carton of very fine herb tea from Old Mexico. We kept him shut up the first couple of days. He is out now and I feel I've let a young tiger loose in the country—He is very cold with me—All of him wants to scratch and bite but I've always been very gentle with him as he only looks at me meanly and slaps the ground with his tail—and doubles up in a curl as if he hates me because for some reason he must not scratch me —

I have one painting

It is a painting—to you—I suppose ~~ another version of that feather—the feather fills the whole canvas—with a grey fluffy feather across it—and just the edge of a whiter one under the very soft grey one—it is bold—12 x 16—not at all what you want from me but some thing I have to say

The god only knows why —

And I think on my next painting is to be of the same idea only different—

I am a little posessed by it.

No one has been here to see me but Lea—my former cook or what not—and Phoebe and Arthur Pack. I gave him one of my best trimmings—I had been mad at him long enough to have it all very clear in my mind and in fine order and I spared him nothing—I drew all the blood I wanted to and wiped my knife clean on what was left of him—He didn't have a leg to stand on—In a way it was

Pretty awful but it was what I thought and felt and I hammered it in one nail after another—Results!

Next day five youngsters from the ranch were sent over on burros with an extra burro loaded with vegetables

39 carrots

16 beets— tops and all

2 cauliflour

2 cabbages

3 large heads of lettuce

I had to laugh —

Well—

I guess that is

alright now—.

I suppose any one else intending to come see me this summer will wait till you come.

Richard had been over the day before I got here—

That is all—I saw Gina here in Santa Fe—She just rubs me the wrong way as I told you. I haven't heard a word from Rebecca—Haven't written her—

I am touched that you offer me a painting Cady—

Have you ever tried just making little drawings—you need so much less material and it is some times fine to see what you can make just a line and black and white do

This is enough Cady—

Remember when your spirit shivers as fears closed in

that I love you widely

like the country

The sun is low with its long shadows—Last night I walked out through the red hills in the moonlight—it was full—tonight I will probably be able to see the color in the cliffs in the moonlight

—yes my friend—it is a wonderful world—maybe even more wonderful—but god the think it gives me most is a kind of quiet. I was so very tired

G.

# Acknowledgments

I dedicate this book to my colleagues Susan Cary and Rihoko Ueno. The book evolved from an exhibition we organized as a team, and their brilliant ideas and research are present throughout the book. Susan and Rihoko, you have convinced me of the importance of cats.

I sincerely thank the Archives of American Art's director, Kate Haw, and deputy director, Liza Kirwin, for encouraging quirky projects like this. Under their leadership, I always feel empowered to highlight the Archives' collections in unconventional and collaborative ways.

I am profoundly grateful to my colleagues at the Archives for discovering many of the most interesting cats in this book and also for patiently enduring my endless puns about cats. Elizabeth Botten, Josh Franco, Michelle Herman, Sarah Mundy, Hilary Price, Jennifer Sichel, and Karen Weiss shared their feline finds with me. Sarah Mitrani gave me a tremendous list of her favorite cats in collections and also digitized almost all of the documents in the book. Megan Burdi thoroughly cataloged every cat and facilitated the transcription of the letters and stories on the Smithsonian Transcription Center website. Marisa Bourgoin solved a few research mysteries, and curatorial interns Katherine Jennings, Christine Muron, Stefanie Sacripante, Ross Schartel, Emily Shoyer, and Chantal Snodgrass helped investigate many inquiries. Sharon Shepard, Toni Brawner, Poreia Duncan, and Vivian Vargas oversaw numerous administrative matters pertaining to the exhibition and book.

I am fortunate to have been in touch with so many curious art historians, curators, and artists, who have supported the project and have given me fascinating insight into the lives of artists, including the names of their cats! I thank Greg Allen, Judy Chicago, Michael Childress, Geoffrey Clements, Robert Cozzolino, Alvaro A. Garcia, Lorri Gunn, Helen M. Z. Harwood, Valerie Hellstein, Robert Indiana, Shaina Larrivee, Leah Leavy, Judith Linhares, Michael Lobel, David Longsmith, Joe Madura, Kathleen Mangan, Allison Martone, Laura McGowan, Michael McGregor, Cyrilla Mozenter, Maria Nevelson, Jennifer Stettler Parsons, Paula Pelosi, David Rasmus, Stephanie Rogers, Emeline Salama-Caro, Carolee Schneemann, Megan Smith, Deborah Solomon, Frank Stella, Isabel Swift, Mike Tighe, Kevin Wallace, and Karl Wirsum.

Special thanks to Kevin Lippert, Jennifer Lippert, Sara Stemen, Paul Wagner, Janet Behning, Valerie Kamen, and Lia Hunt at Princeton Architectural Press for thoughtfully shaping the content of this book into a beautiful and accessible publication.

Finally, I thank Will, Baby John, and my elderly pug, Betty. Perhaps it is time for us to get a cat.

Mary Savig is the curator of manuscripts at the Smithsonian's Archives of American Art and the author of *Pen to Paper: Artists' Handwritten Letters from the Smithsonian's Archives of American Art*.